forgotten

TALES

of

PITTSBURGH

forgotten TALES of PITTSBURGH

Thomas White

illustrations by
Kyle McQueen

THE
History
PRESS

Published by The History Press
Charleston, SC 29403
www.historypress.net

First published 2010
Second printing 2013
Third printing 2013

Manufactured in the United States

ISBN 978.1.60949.071.3

White, Thomas.
Forgotten tales of Pittsburgh / Thomas White.
p. cm.
Includes bibliographical references.
ISBN 978-1-60949-071-3
1. Pittsburgh (Pa.)--History--Anecdotes. 2. Pittsburgh Region (Pa.)--History-
-Anecdotes. 3. Pittsburgh (Pa.)--Social life and customs--Anecdotes. 4.
Pittsburgh Region (Pa.)--Social life and customs--Anecdotes. 5. Pittsburgh
(Pa.)--Biography--Anecdotes. 6. Pittsburgh Region (Pa.)--Biography--Anecdotes.
7. Curiosities and wonders--Pennsylvania--Pittsburgh--History--Anecdotes. 8.
Curiosities and wonders--Pennsylvania--Pittsburgh Region--History--Anecdotes.
I. Title.
F159.P657W47 2010
974.8'86--dc22
2010046682

For my brother, Ed

Acknowledgements

I want to take this opportunity to thank everyone who helped me while I was writing this book, especially my wife, Justina, and my children, Tommy and Marisa. Also I want to thank my parents, Tom and Jean, and my brother, Ed, for their support. Paul Demilio, Renee Morgan, Aaron Carson and Elizabeth Williams took the time to help proofread yet another of my manuscripts. Their input was greatly appreciated. Many other people made important contributions to this book in one form or another and pointed me in the direction of useful information, including Laura Lindsay, Mary Mikulla, Emily Jack, Ken Whiteleather, Vince Grubb, Brian Mckee, Kurt Wilson, Tony Lavorgne, Brett Cobbey, Dan Simkins, Brian Hallam, Kelly Anderson, Brian and Terrie Seech, Joshua Beatty, Dr. Joseph Rishel, Dr. Perry Blatz, Art Louderback, Bob Stakeley and Michael Hassett. I would also like to thank Hannah Cassilly and the rest of the staff at The History Press for allowing me to write another volume in their Forgotten Tales series.

PREFACE

A little over a year before I penned the text that you are reading now, I completed a book for The History Press called *Forgotten Tales of Pennsylvania*. It was a collection of brief tales, meant to be entertaining, about little-known events, people and folklore from around the state of Pennsylvania. I had gathered the stories over the past decade or so while researching the history of this state, especially the western part of it. Though that book contained over 160 anecdotes, it was only a fraction of the odd stories that I had amassed about the commonwealth of Pennsylvania. My hometown of Pittsburgh had enough forgotten tales to fill more than one volume alone, so I took some of those stories and put them into this book.

These *Forgotten Tales of Pittsburgh* cover a variety of subjects including murders, mass panics, forgotten forts, historical firsts, animal attacks, curses, ghost stories, explosions, heroes, miracles and many others. A few

of the tales are downright bizarre in nature, such as a spontaneously combusting woman, a talking dog and Nikola Tesla's death ray. One story even tells of a suspect in the Jack the Ripper killings who lived in the city. Though some of these tales may be familiar to the more avid students of Pittsburgh's history, I'm sure that even they will find something new here.

The tales that are included in this book come from a variety of sources. Many are from old newspaper articles, archival documents, lesser-known books and historical journals. Though these stories are meant to be brief, I attempted to include all of the key details that I was able track down. With a few of the tales, limited information was available, and I will sometimes point that out in the text. The only criteria that I used for selecting these stories are that they were relatively unknown and occurred within the Greater Pittsburgh area. I hope that you enjoy reading them and learn some of Pittsburgh's unusual history in the process.

Forgotten Tales of Pittsburgh

Westsylvania: The State That Could Have Been

Pittsburghers and other residents of western Pennsylvania have always been a little isolated from the more densely populated eastern half of the state. Ever since the late colonial era, they have often felt underrepresented in the state government as well. Just before the American Revolution, what is now southwestern Pennsylvania was claimed by Virginia in addition to Pennsylvania because of vague land grants. The Mason-Dixon line had not yet been extended that far to the west, and the western colonial borders were not set. Easterners tended to view the frontier region that is now southwestern Pennsylvania as little more than an unruly backwater. In 1769, some of the competing land speculators from the two states joined forces to create the Grand Ohio Company, and their goal was to create a new colony called Vandalia to the west of

the Appalachian Mountains. This colony would benefit the company and its investors and help bring order to the confusion on the frontier. Their efforts were slow to gain support, however, and became irrelevant when the American Revolution began.

The idea of a new independent state on the western side of the Appalachians did not disappear with the Grand Ohio Company. Residents of Pittsburgh and the Ohio River Valley resurrected the idea in 1776. They believed that the colony-turned-state governments of the eastern seaboard, which were busy planning the War for Independence, were neglecting the security of the frontier. Indian raids, often spurred by the British, caused terror and turmoil. It was thought that a new state could use its authority to provide a better defense from the Indians and settle local land disputes. This new state, called Westsylvania, would have its capital in Pittsburgh and include all of modern southwestern Pennsylvania, most of what became West Virginia and the eastern edge of Kentucky. A petition was sent to the Second Continental Congress, but it was ignored. The Congress was dealing with other pressing issues and feared that establishing another state on the frontier would just increase the problems. In an attempt to end the talk of a new state, the government of Pennsylvania made it a capital offense to publically discuss the issue.

This law did not stop the idea of Westsylvania from lingering for decades. Though the issue was not pressed in 1776, the state government in Philadelphia was too far

away to enforce such a law anyway. After the war, perceived political neglect and economic uncertainty continued to feed the idea of an independent Westsylvania. When the federal government finally dealt with the hostile Indian tribes in the early 1790s, one of the complaints was finally addressed.

However, the federal government also brought a new problem in 1791—a federal excise tax on whiskey. Whiskey was vital to the economy of western Pennsylvania (one quarter of all whiskey stills in the country were here.) It was even used as currency in place of depreciating paper money because whiskey held its value. The new tax unfairly targeted small producers and was viewed as unnecessarily burdensome by western Pennsylvania's struggling residents. The independent attitude of the area's population led them to take matters into their own hands by refusing to pay the tax and harassing the collectors. The subsequent Whiskey Rebellion in 1794 was accompanied by comparisons to the ideals of the American Revolution and calls for independence by some of the more radical rebels. When the rebellion was suppressed by the federal army, led by George Washington himself, the final call for a state of Westsylvania was silenced.

CREEPY CLOWNS AND COSTUMED MENACES

In the early days of June 1981, Pittsburgh experienced an invasion of evil clowns and other costumed characters. At

least, that is what many children and parents throughout the East End and other neighborhoods believed. Rumors had circulated that a variety of costumed men had been approaching children, attempting to lure and abduct them. Some were said to be clowns or men in gorilla suits. Others reported that they had seen men dressed as Spider-Man and other superheroes. Soon police were receiving ten to fifteen calls a day about the mysterious

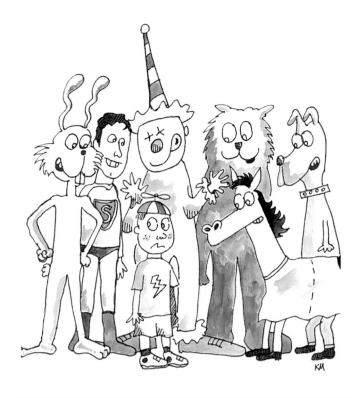

clown and his cohorts. Frightened parents demanded action, but the police had no solid leads and no actual evidence of a crime.

One of the early reports came in on June 1. A boy in Arlington Heights claimed that three men, one dressed as a clown, one as a gorilla and one as Spider-Man, attempted to convince him to get into their car. The boy said he ran away from the men. The next day, however, when police questioned the boy, his story started to fall apart. He admitted that he had fabricated the entire thing, perhaps after hearing the other rumors. Before the police could spread word of the hoax, a well-meaning individual in Arlington Heights started handing out fliers warning of the three costumed individuals.

At the same time, the costumed characters were reported in various East End neighborhoods. Word spread that some of the men had raped and murdered a young girl. This was not true, but it was widely believed. Some children in Oakland claimed that the man dressed as Spider-Man had been seen on a roof with a shotgun. Allegedly he was shot and killed by police snipers and fell to the sidewalk below. In Garfield, a man dressed as Superman was supposedly apprehended after trying to lure children. He was carrying a variety of knives in his cape. Neither occurrence actually happened, but rumors spread quickly. Many young people acted as if they were fact.

Police did investigate a report that a strange clown was seen by schoolchildren on Bentley Drive in Terrace Village.

The clown had allegedly fled into the woods on a hillside. Canine units were called in, and in what would now be viewed as a questionable move, the police allowed about one hundred of the children armed with sticks and clubs to sweep the woods with them. The evil clown was never found, of course.

Many of the calls that police received were reports of costumed figures trying to lure children into cars and vans. Though many incidents were brought to the attention of the police department, they almost never involved vehicles of the same color or make. In one instance, police were looking for a man in a rabbit costume who was driving a blue van through Garfield and Bloomfield. As they searched, a call came in that the rabbit had entered the Tiger's Tail bar on Penn Avenue. It just so happened that a beat cop was walking right outside the bar at the time. He entered and searched the premises immediately but found no trace of the strange rabbit/man. The following night, the rabbit was seen in Allegheny Cemetery in Lawrenceville. He was supposedly accompanied by Spider-Man. Another thorough search yielded the same results. No costumed men were found. One of the cemetery's security staff reported that he had heard that the man in the gorilla suit had been sighted there as well.

The *Pittsburgh Press* found that most of the reports during the panic were actually from second- or third-hand sources. Many came from parents who had heard stories from their children, who had heard the rumors in school. One of

the few direct reports came from two boys who had seen the rabbit. They did not want to be identified because they feared that the rabbit would find them and kill them. Pittsburgh Police believed that the reports were a form of mass hysteria, possibly sparked by media coverage of the Atlanta child murders that were occurring at the time. At least twenty-eight black children and adults were brutally murdered, mostly by asphyxiation, in the Atlanta area from 1979 to 1981. At the time of the clown and superhero sightings in Pittsburgh, no suspects were in custody in Atlanta. In fact, the flier that circulated in Arlington Heights referenced the murders. Similar reports of creepy clowns were occurring in Boston and Kansas City around the same time. It may have been part of a national reaction to the brutal crimes or fear of copycat killers.

After the *Pittsburgh Press* article ran, reports of the creepy costumed figures began to slow. Though schoolchildren were still warned by their teachers in the fall not to go anywhere with the unusual strangers, the hysteria diminished in the minds of adults. Some rumors circulated again around Halloween, but that was not unusual. Eventually the children stopped thinking about the costumed menaces as well.

THE CHICORA METEOR

On June 24, 1938, the skies over Pittsburgh and western Pennsylvania were illuminated by a massive explosion.

Twelve miles above, a 450-metric-ton meteor exploded in the atmosphere with the force of 10,000 tons of TNT. The sound could be heard for miles. Had the meteor struck the ground in a populated area, it could have caused severe destruction. If it had landed in downtown Pittsburgh, it might have damaged a sizable portion of the city and caused numerous causalities. Luckily, most of the meteor did not survive its journey through the atmosphere. One fragment did come down in a field north of Pittsburgh near Chicora, Butler County. It allegedly struck and killed a cow. The meteorite fragment was recovered and was divided between the Carnegie Museum of Natural History and the Smithsonian. Several smaller fragments were recovered around the region over the next couple of years.

JOB'S HOLE

There is a legend that circulated for decades in the Allegheny River Valley about the origin of a peculiarly named area near Tarentum. The community of Job's Hole was once nestled in a hollow near the bend in Bull Creek. According to the story, a teamster named Job regularly drove his wagon (or wagons, depending on which version you hear) on the land along the creek sometime during the mid- to late 1800s. Job's ethnicity varies with different versions of the tale, probably in response to changes in the community's ethnic makeup over time. Sometimes he

is described as white; other times he is black. Some tales identify him as an immigrant. One version of the story recounts the day when Job drove his wagons onto a clear but wet-looking patch of land near the creek. He did not realize it, but the horses had walked right into quicksand. Before Job could react, they all started to sink. The more that the horses struggled, the faster they were pulled down. Job and the wagons disappeared into the ground, never to be seen again.

A more plausible variation of the tale sets the tragedy at the confluence of Bull Creek and Little Bull Creek. As Job tried to cross the creek atop his wagon, his lead horses stumbled into a previously unknown hole on the bottom. Job and the wagon were pulled in with them and drowned. Job, his wagon and his horses were never found. Hence the nearby community was named Job's Hole. Much of the community later vanished in the late 1970s when the Allegheny Valley Expressway was constructed. Most of the homes had to be razed for the new highway, but it did not stop the legend from surviving in the surrounding communities.

THE FIRST ALUMINUM OBSERVATORY DOME

Leo Scanlon was always interested in astronomy. In 1929, he helped to start the Amateur Astronomers Association of Pittsburgh. In 1930, he achieved a first in the field of astronomy. Just off Mcknight Road near Ivory Avenue,

in the area known as Summer Hill, he constructed the world's first aluminum observatory dome. He had been told by experts that a self-supporting aluminum dome was unfeasible. Scanlon and his brother proved them wrong. The structure that they built became known as the Valley View Observatory.

Scanlon constructed the dome because of the difficulty in viewing the stars so close to the city. Light pollution from nearby streetlights made traditional telescopes all but useless. When the historical marker that commemorates the dome was dedicated in 1998, Scanlon admitted that he tried to black out the streetlights with shoe polish. When that did not work, he even resorted to shooting them out with an air rifle, but they would be quickly replaced. It was then that he came up with the idea of building the dome to block out the surrounding light. Aluminum proved to be the ideal material for his small observatory. Scanlon's dome was copied around the country and the world and became the model for many amateur observatories.

An Old Ghost Story

In the 1830s, the McFarland family lived in a log farmhouse in the area that would become Wilkinsburg. The home was situated very near to the location of what was later the Singer Mansion. During that time and decades after, residents told stories about the ghost in the McFarland home. Though

only sketchy details remain, it is one of the oldest ghost stories in the Pittsburgh region. The ghost apparently made itself known frequently and would often groan and make other noises. The practical and hardworking McFarlands did not allow themselves to be bothered by the ghost. The same could not be said for other visitors and guests. On one occasion, two friends of young Mary McFarland stayed the night at the house. Early the next morning, the two girls, in an attempt to help, were bringing the ashes from under a coal grate down the stairs in a bucket. As they were descending, the ghost suddenly moaned. The second girl jumped when she heard the sound, sending both girls and the ashes tumbling down the stairs. In later years, the property was purchased by John Singer. The old log house was torn down, but strange noises and happenings were rumored to continue on the property. It is not clear if the McFarlands ever had any idea or guesses as to the identity of the ghost.

PITTSBURGH'S CIVIL WAR FORTS

In the spring and early summer of 1863, the residents of Pittsburgh were worried that the city would be attacked by the Confederate army that was working its way north. The city was home to numerous industries that were vital to the Union's war effort. The Confederacy could strike a crippling blow by capturing the city. To defend Pittsburgh

from possible invasion, a series of forts and earthworks were hastily constructed in June of that year. The goal was to encircle the city, defending strategic points. Many of the forts were not even completed by the time that the news of the Battle of Gettysburg reached the city, essentially making them unnecessary. Most were never fully manned. Portions of these forts and earthworks remained visible well into the twentieth century, but only a few remnants survive today. For the most part, Pittsburgh's Civil War–era fortifications have been forgotten. Historian and archaeologist Bill McCarthy completed a detailed survey of the forts and identified their locations as best as possible.

On the western side of Pittsburgh, two unnamed earthworks were constructed. One was located near or possibly at the location of the West End Overlook. Securing that location helped to control the river below. The other was located off East Steuben Street in Crafton Heights. Several forts were constructed to the south of the city. Fort Robert Smalls was constructed behind St. Peter's Cemetery in Arlington Heights. Fort Laughlin, sometimes called Fort Ormsby after the landowner, was located in Arlington Park. On the site of St. Joseph's Church in Mount Oliver was Fort Jones. Both Fort Jones and Fort Laughlin were constructed by employees of the Jones and Laughlin Mill on the South Side. Unnamed fortifications were present at the intersections of Arlington Avenue and Proctor Way and at Warrington Avenue and Beltzhoover Avenue. The latter was a powder magazine. Fort Mechanic was located

along Bailey Avenue. Part of the fort would later become the site of the Castle Shannon Incline. Fort McKnight was constructed at Prospect and Cowan Streets, on the site of what became Prospect School. Three other unnamed fortifications were located along Fingal Street and another near the top of the Duquesne Incline.

Numerous fortifications were also engineered to the east of the city. Construction began on a fort along Turtle Creek behind what is now the Braddock Cemetery, but it is not clear if it was ever completed. It was meant to protect the Pennsylvania Railroad yard and the Port Perry sawmill. Fort Black, in Greenfield, was the largest of the fortifications and the only "true" fort, according to McCarthy. It was located between Parade and Shields Streets along Bigelow Street. The fort had wooden walls and earthworks. By the early twentieth century, children used the remains of the fort as a playground. A swing was attached to the gate, and the ditch was filled with water so it could become a makeshift ice-skating area in cold weather. The interior of the fort became a baseball field. During World War I, it was used as a training ground for soldiers, and in the late 1920s, the site was allegedly used for Ku Klux Klan rallies. Eventually the fort was leveled and replaced with housing. Fort Herron was located on Herron Hill near the reservoir. It was always fully manned and considered vital to Pittsburgh's defense. Fort Anderson was built on what is now University Drive in Oakland. Fort Negley was situated on Hillcrest Street, not far from the home of Judge Thomas Mellon. It was named after landowner Jacob Negley. At the

intersection of Stanton Avenue and Morningside Streets, Fort Croghan was constructed near the edge of the Croghan-Schenley estate. Ten other unnamed fortifications were built in key locations to the east of the city.

North of Pittsburgh were five more defensive works. Fort McKee was located in Manchester along Colfax Street. It survived until the 1930s, but the site was eventually covered by housing. Fort Brunot was constructed on what later became the site of the Pressley Ridge School on Marshall Avenue. Another unnamed fort was constructed where Marshall Avenue meets Perrysville Avenue. A fort was also constructed at what would become St. Nicholas Cemetery in Reserve Township. The final fort, named Fort Fulton, is the only one with any substantial part still intact. About half of the original earthworks have survived because they are situated under a broadcast tower off Mount Pleasant Road, on the hill across from Northview Heights. The site was originally an orchard that had been abandoned. Fort Fulton was circular and had a diameter of over seventy-five feet. The outer ditch, part of which is still intact, was about six feet deep.

That's What You Get for Stealing a Chicken

William Charles McFarland and his friend Herman Sanderbeck came up with a plan. They had been drinking heavily on the night of November 9, 1935, in New Brighton, Beaver County. Sometime late in the evening they realized

that they were out of money. This was a problem, because they wanted to keep drinking. In their intoxicated states, McFarland suggested that they steal some chickens to trade for moonshine. He told Sanderbeck to wait up on a hillside while he ventured off to complete the plan.

Sanderbeck eventually told police that a little while later, McFarland walked up the hill with a jug of moonshine—and a gunshot wound! McFarland said that someone had shot him when he raided a chicken coup. Apparently, that did not stop him from making the trade. Sanderbeck found another friend (who was probably also intoxicated) to help get McFarland home. He was brought to his mother's house in the middle of the night, and she put him to bed, thinking he just had too much to drink. Apparently she failed to notice that he was bleeding and his friends failed to point out that he had been shot. When his mother checked on him in the morning, he was dead. Only then did she see the bullet wound, and she had no idea where it came from. The police were baffled until they picked up Sanderbeck on November 20, coincidently, on an outstanding charge of chicken theft. Sanderbeck told them the story behind McFarland's injury after he was questioned about recent thefts.

Streetcar Collision

In the traditional fashion, a large crowd had gathered in the summer of 1897 to watch a Fourth of July fireworks

display in Schenley Park. When the display was over, the crowd dispersed. Many boarded streetcars to return home. As an Atwood streetcar went down Soho Hill, it jumped the tracks about halfway. Soon a second, open-top car pulling a trailer came down the hill. It was crowded with people and was moving too fast to stop, and it collided with the derailed car. A third car, also loaded to capacity, came down the hill at full speed. It slammed into the other two cars. Four people sustained fatal injuries. At least seventeen other passengers received injuries severe enough to be taken to the hospital. Most were in the open-top car. All of the streetcars involved belonged to the Consolidated Traction Company.

MURDER ON BOYD'S HILL

Today Boyd's Hill is known as the Bluff and is home to two of Pittsburgh's oldest Catholic nonprofit organizations: Duquesne University and Mercy Hospital. In the mid-1800s, however, the Bluff looked completely different. The Boyd's Hill neighborhood was made up of the homes of mostly immigrant families (Irish, German and Welsh) and small businesses. Residents of the usually uneventful neighborhood received a shock on August 24, 1865, when the mutilated remains of a man were discovered. The body was found in an old brickyard near the top of Magee Street. The victim had his throat slashed from ear to ear; his body

was riddled with numerous stab wounds; and his face was mutilated badly.

Police were unable to identify the dead man, and they had little evidence to aid their investigation. Several men were taken into custody on suspicion of involvement in the crime. They were released for lack of evidence but were watched closely. One month later, on September 24, police managed to get a voluntary confession out of a German immigrant named Benjamin Bernhart Mareschel (or Marshall.) He had been arrested after breaking into a home on Wylie Avenue. Police then went to his house on Boyd's Hill to search for stolen property. Instead of stolen goods, they found bloody clothing.

Mareschel claimed to have met the dead man and another immigrant named August Frecke in New York. He did not know the dead man's name, but the trio traveled together to Pittsburgh on a train. During the trip, he and Frecke had become convinced that the dead man was carrying a large amount of money. The two made a pact to kill the man and split his cash.

After arriving in the city, Mareschel invited the men to his home on Boyd's Hill. It was there that the murder took place. Frecke stabbed the man repeatedly while Mareschel struck him three times on the head with an iron bar. They threw the murder weapons into the Monongahela River. Frecke made a statement to police in an attempt to exonerate himself and shifted most of the blame to Mareschel. When word escaped that the men had been arrested, hundreds

lined the streets to watch them en route to the jail. Both men were convicted and hanged in early January 1866. The dead man's last name was eventually determined to be Foerster.

THE SATANIC PANIC COMES TO PITTSBURGH

In the late 1970s and early 1980s, rumors of dangerous and clandestine satanic cults circulated throughout the country. They suddenly seemed to be everywhere, performing sacrifices, ritually abusing and abducting children and even infiltrating companies. During the '70s, there was a marked increase in public interest in occult topics, one of which was Satanism. Frightening movies such as *The Exorcist* and *Rosemary's Baby* were popular, and the media carried headlines about the Son of Sam murders and the mass suicide at Jonestown. By the early 1980s, accusations of satanic ritual abuse had been raised against day-care providers in California and later in other states. Many of these accusations were based on the now discredited technique of recovering "repressed" memories of alleged victims through hypnosis. Rock music, household products and even children's games were linked with Satanism during the scare that lasted into the early 1990s.

Pittsburgh saw its share of satanic rumors during that time. In 1984, a typewritten leaflet circulated in Pittsburgh communities warning that the company Proctor & Gamble

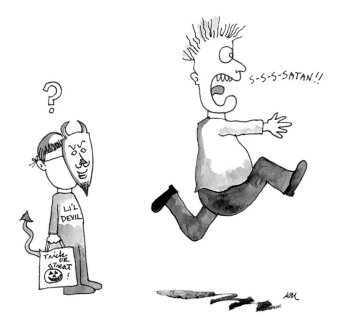

was tied to the Church of Satan. It claimed that the president of the company had admitted to it on television. The pamphlet also claimed that the company's logo, a man-in-the-moon face, contained the number 666 and was a satanic symbol. The company received over eight thousand calls from concerned customers in the area. Though the rumor had actually originated elsewhere, it had a tremendous impact in western Pennsylvania. It was a total fabrication. There was never any television appearance, and the company logo was designed in the 1850s. The sixes

were merely curls in the man in the moon's beard. Proctor & Gamble had to take legal action for decades to stop the slanderous rumor as it spread around the nation.

By the late 1980s, more stories were circulating. The evil cults allegedly kidnapped and sacrificed victims in isolated locations throughout the region. In North Park, a cult was said to perform dark ceremonies on Blue Mist Road (its real name is Irwin Road). Since the heavily wooded road was closed to traffic, it inspired the rumors of nefarious happenings. It was not uncommon to hear stories of the discovery of human and animal sacrifices. Of course the lack of news coverage of these alleged crimes only fueled the idea that the cult had the influence to cover them up. Other places in the area had similar stories attached to them, including Shades of Death Road in Washington County and the Old Quaker Church (Providence Meetinghouse) in Fayette County.

In February 1989, stories circulated that some teenagers had discovered a satanic worship site in the woods near Aliquippa. A large rock served as the altar, and on it they found a black, leather-bound satanic bible and a rotting animal hide. The rumors spurred a police investigation. It turned out that the "satanic bible" was just a copy of the New Testament that a local man had accidently left in the woods. The rotting animal hide was just an old wool sweater.

Sometimes it was not just teenagers and concerned parents who found themselves wrapped up in the

panic. Many area teachers and police received training on Satanism. In March 1989, some police officers in Kittanning attended a seminar on satanic crime. A few days later, they spotted what they believed to be a satanic worship site. After a quick raid they discovered that what they thought was an altar was only a grill modified to hold beer kegs. The pews for cult members that they believed were surrounding the altar were, in fact, only picnic benches. In Lawrenceville, Pittsburgh police staked out a wooded area that was said to be the location of cult activity and sacrifices. After several long nights, it was determined that the story was only a rumor.

Various drug treatment centers and psychiatric facilities in Pittsburgh reported a rise in the involvement of teenage patients in satanic practices. Most of these reports were of self-confessed Satanists, many with drug addictions and not large, organized cults. How satanic practices were defined was another issue. For some observers, listening to heavy metal was enough to have one put in the category. It is not clear if any of these individuals actually worshipped the devil or if it was merely part of teenage rebellion that had gone too far. While there certainly were actual Satanists, their numbers and activities were much more limited than what the public had imagined. Eventually the moral panic subsided but not without leaving a lasting mark on those who were drawn in.

COUNTERFEITING BEHIND BARS

The warden in charge of Riverside Penitentiary made a shocking discovery in October 1897. Apparently, several convicts in his prison were running a counterfeiting operation right under his nose. After all, why should they let prison ruin a good scam? The prisoners were making fake fifty-cent pieces. A search of cells turned up several molds and scrap metal that were used to make the coins. Someone on the inside must have been helping the convicts because many of the coins had made it out of the prison and into circulation. They were unable to determine who started the operation.

PITTSBURGH'S CHINATOWN AND THE TONG WARS

Many modern Pittsburghers might be surprised to know that the city once had its own Chinatown. It was not very large, but it was a busy center of commerce for the local Chinese immigrants and their families, most of whom hailed from the Canton region. The small ethnic neighborhood was located between Second Avenue and Third Avenue and Ross and Grant Streets. The first immigrants moved into that location around 1887. Previously those of Chinese descent had been clustered in small pockets around the city. The neighborhood was home to many business, restaurants and merchants, as well as families, a small park

and a Chinese school. Imported goods from China, such as tea and decorative items, were readily available. Large community celebrations, like Chinese New Year, were held in the neighborhood as well.

Though most of the immigrants in the community were from the same region of China, things were not always peaceful. Two rival fraternal organizations, often called Tongs, existed in Chinatown. Though Tongs started as a way to aid immigrants and businesses, they often came to dominate local commerce in Chinatowns around the country. They were also very territorial and sometimes broke the law. Some even ventured into larger criminal enterprises in later years. One was Hip Sing (meaning Help-Success), located at 529 Second Avenue, and the other was On Leong (meaning Peace-Fraternity), located at 522 Third Avenue. The Tong activity in Pittsburgh was rather tame compared to places like New York, but there was still occasionally violence.

Between 1924 and 1931, there were skirmishes between the two groups in the city. The violence was not just contained to Chinatown but also occurred at other Chinese-run businesses in the area. Gunmen entered a laundry business at 509 Rebecca Street in Wilkinsburg on January 19, 1925, in an attempt to kill fifty-four-year-old Wah Lee. Lee ducked in time, but eighteen-year-old Won Ton Fan was struck with two bullets; Fan survived the attack. It was believed at the time that the gunmen were attempting to avenge the death of Yee Jung Chen, who was murdered in

a different laundry a month before. The gunmen had been seen arriving in Chinatown the day before. Apparently their purpose or identities must have been known to the police, because they attempted to follow them. However, the gunmen seemed to vanish into the neighborhood, given shelter, no doubt, by one of the Tongs.

In another instance, a former member of the On Leong branch of New York was gunned down after fleeing to Pittsburgh. Lee Sam had apparently stolen $40,000 from On Leong and went to Pittsburgh to join Hip Sing in October 1924. On Leong did not tolerate the theft and had Lee Sam killed in Chinatown. Over the next two years, there would be more sporadic killings in Chinatown and Wilkinsburg. A battle between the two sides erupted at the corner of Grant Street and Third Avenue in late March 1927. Two members of On Leong were shot, and police arrested five members of Hip Sing.

By the early 1930s, the Tong wars had stopped in this area, and Chinatown was facing new problems. The neighborhood was disrupted by the construction of the Boulevard of the Allies, and many of its residents decided that it was time to leave. As the city changed, Chinatown continued to dwindle. In 1934, there were only ten stores remaining, and by the 1950s, only three families remained. Today, the only remnant of the once thriving community is the Chinatown Inn on Third Avenue, easily recognized by its façade.

A STREETCAR DISASTER

A terrible streetcar accident occurred in Pittsburgh just before Christmas in 1917. It involved one of the newest cars on the Knoxville trolley line. On Christmas Eve, the car picked up speed and jumped the tracks at the end of the Mount Washington Tunnel. The car separated from the line and launched into the station platform at Water and Carson Streets. The platform was covered with people (mostly women and children) who were shopping for Christmas. The car plunged through the wall of people, tore through the back of the platform and landed in an embankment on its side.

Approximately 114 people were in the car when it went out of control. Dozens of others were at the station. Fourteen died at the scene, many of whom were crushed by the car. Seven more people died later at area hospitals. Eighty-two people had serious or severe injuries, and numerous others suffered minor wounds and bruises. Newspaper accounts stated that the accident happened so fast that people did not have enough time to clear the platform. By the time the screams of the trolley passengers could be heard, it was too late.

It was believed that the switches at the station had caused the detached car to vault into the air. Other reports stated that the lights in the tunnel had gone out around the time of the derailment. The motorman told authorities that he lost his brakes. The slick rails added more velocity to the

runaway car. Numerous lawsuits resulted because of the accident. The cost of the settlements caused the Pittsburgh Railways Company to declare bankruptcy. Though the company would recover briefly, the accident marked the beginning of the decline of streetcars in Pittsburgh.

FORGOTTEN FORT FAYETTE

Fort Fayette was the last of the colonial and early American forts that were constructed in Pittsburgh. Though it is not as well known as its predecessors—Fort Duquesne and Fort Pitt—it served an important role in the Indian wars of the 1790s and later in the War of 1812. It also served as a staging ground for the Lewis and Clark expedition while they gathered supplies in the city.

By the 1790s, Fort Pitt, near the point, had long been in disrepair, so a new location was chosen for the new fortification. Fort Fayette was built in 1792 along what is now Ninth Street between Liberty Avenue and the Allegheny River. A series of conflicts with the Indians of western Pennsylvania and eastern Ohio made the fort necessary. Relations with the tribes had deteriorated in the 1780s after the Gnadenhutten massacre, the killing of Colonel William Crawford and the burning of Hannastown. The United States Army had been unable to subdue the tribes, and in 1791, General Arthur St. Clair's expedition was defeated. Pittsburgh and western Pennsylvania were temporarily

defenseless. Construction on Fort Fayette began as a new military expedition was dispatched to handle the Indians. It was led by Revolutionary War hero General "Mad" Anthony Wayne. Wayne temporarily stationed and supplied his troops at the fort before moving them downriver to Fort McIntosh. Fort Fayette continued to serve as the anchor in his supply chain as his troops moved into the Ohio territory. In 1794, Wayne defeated his Indian opponents at the Battle of Fallen Timbers, and the conflicts in western Pennsylvania were brought to an end.

Fort Fayette was physically smaller than Fort Pitt. Its outer walls were approximately fifteen feet high, and there were four bastions. Three of the bastions were brick-strengthened blockhouses and the fourth was a powder magazine. Inside the fort were two barracks, one made of bricks for the officers and a larger one made of logs for the enlisted men. The gate and guard house faced the city, and next to it was the prison. Some of the remaining pieces of artillery at Fort Pitt were apparently moved to Fort Fayette.

After the Indian wars, a small garrison was occasionally stationed at the fort. When the War of 1812 began, it was used to supply the forces of Commodore Oliver Hazard Perry. Once Perry's forces departed, the U.S. military decommissioned the fort in 1813 and prepared to sell it. Fort Fayette was finally taken down in 1815. Today, a historical marker stands at the site.

TROTTER'S CURSE

The legend of Trotter's curse dates back to the early 1790s when the forces of General "Mad" Anthony Wayne were stationed at Fort Fayette in Pittsburgh. Wayne was using the fort as a base of operations as he waged a campaign against hostile Indians on the frontier north and west of the Allegheny River. According to the legend, Wayne found himself dealing with numerous desertions among his troops. To curtail the problem, the general ordered that all deserters who were caught be executed immediately.

Since there was also a lot of "down time" at the fort, the troops and General Wayne himself were known to engage in long drinking binges. One particular time, the general was said to be intoxicated for several days. During that binge, one of his aides named John Trotter approached the drunken general with a request. He asked Wayne if he could have a brief leave of absence to assist his family who lived a few days east of the fort. The drunk and angry general told Trotter that he could do whatever he wanted, as long as he left him alone. Trotter left to visit his family, believing that he had permission.

A few days later, while drinking again, General Wayne called for Trotter. The other soldiers reported that he was not at the fort. Forgetting his previous drunken conversation with Trotter, Wayne became enraged and sent three soldiers to apprehend the "deserter." When Wayne sobered up and

realized what had happened, he sent word to cancel his order of execution. It was too late.

The three soldiers, Colonel Robert Hunter, Captain William Elliot and John Horrell, caught up with Trotter in Hannastown. He was on his way back to Fort Fayette. Trotter told the men his story, and though they were sympathetic, they feared that if they did not carry out the order, they would be punished. After the reading of the execution order, Trotter requested a Bible. He turned to Psalm 109, also known as the Prayer of the Falsely Accused, and read:

> *Hold not your peace, O God of my praise; For the mouth of the wicked and the mouth of the deceitful are opened against me: they have spoken against me with a lying tongue. They compassed me about also with words of hatred; and fought against me without a cause. For my love they are my adversaries: but I give myself to prayer. And they have rewarded me evil for good, and hatred for my love. Set you a wicked man over him: and let Satan stand at his right hand. When he shall be judged, let him be condemned: and let his prayer become sin.*

Trotter continued in a deliberate and stern voice:

> *Let his days be few; and let another take his office. Let his children be fatherless, and his wife a widow. Let his children be continually vagabonds, and beg: let them seek their bread also out of their desolate places. Let the*

extortionist catch all that he has; and let the strangers spoil his labor. Let there be none to extend mercy to him: neither let there be any to favor his fatherless children. Let his posterity be cut off; and in the generation following let their name be blotted out. Let the iniquity of his fathers be remembered with the Lord; and let not the sin of his mother be blotted out. Let them be before the Lord continually that he may cut off the memory of them from the earth. Because that he remembered not to show mercy, but persecuted the poor and needy man, that he might even slay the broken in heart. As he loved cursing, so let it come to him: as he delighted not in blessing, so let it be far from him. As he clothed himself with cursing like as with his garment, so let it come into his bowels like water, and like oil into his bones. Let it be to him as the garment which covers him, and for a girdle with which he is girded continually. Let this be the reward of my adversaries from the Lord, and of them that speak evil against my soul.

When he was finished with the rest of the verse, the three soldiers stood in silence. The men realized that Trotter had called down a curse upon Wayne and themselves. A moment later, they fired the shots that ended Trotter's life. According to the legend, the three soldiers actually believed that they were cursed, and so did their neighbors.

For the rest of his life, Colonel Hunter suffered from what appeared to be an extreme form of diabetes. He was

continually thirsty, and no matter how much he drank, the thirst never went away. Hunter was continually miserable and became an outcast in the community. His death finally came in Bairdstown, Westmoreland County. Captain Elliot lived for a while in New Alexandria, Westmoreland County, before moving to Butler County. He was known to be an alcoholic. Elliot was convinced that he was being followed by a demonic dog for the rest of his life. He insisted that it would even enter his house by jumping through the windows. Elliot would see the dog when no one else could, and everyone thought him to be mad. John Horrell spent the rest of his life in Loyalhanna Township. He believed that he was possessed, and that sometimes the devil came to torment him. Every evening at midnight he would be thrown from his bed onto the floor. He even claimed to have seen the devil peek out from behind his headboards and stare at him with evil glowing eyes that burned like coals. Horrell was allegedly killed when a demon, in the form of a white goose spewing sulfur from its nose and mouth, spooked his horse. Horrell was thrown from the animal and died from his injuries.

General Wayne did not escape the curse. Allegedly he told friends that he would frequently receive nighttime visits from the ghost of Trotter. The apparition would appear at the foot of his bed and stare in silent accusation at the general.

DRIVER SAVES CHILD'S LIFE—AND IS FINED!

One day in early June 1925, Pittsburgh lawyer Richard C. Long was driving home from a golf tournament. He left the Allegheny Country Club in Sewickly Heights and traveled toward Pittsburgh. When he passed through Emsworth, a tragedy was narrowly avoided due to Long's quick reflexes. A little girl and an Irish terrier suddenly darted into the path of Long's car. He quickly swerved into the other lane, narrowly missing the girl and her dog. Luckily, there was no oncoming traffic.

A police officer on a motorcycle witnessed the event. He decided that Long should be rewarded with a ticket and a summons to appear before the justice of the peace. The reason—Long crossed the line painted on the road. Long appeared before A.A. Davis and received a fine of twelve dollars. He ended up paying fifteen dollars, however, because they charged him three dollars for a copy of the transcript. They did not accept his argument that it was permissible to cross the painted line to save a child's life.

NOT QUITE A TORNADO, BUT JUST AS DESTRUCTIVE

Tornados are a relatively rare occurrence in Pittsburgh. The hilly terrain has traditionally provided some level of protection, but as seen in the past, there are occasionally destructive twisters in western Pennsylvania. Powerful

windstorms are more common, and they sometimes have tornado-strength winds. In early January 1889, one of these freak windstorms struck Pittsburgh. Though it was sometimes described as a tornado in the papers, it was actually a storm with hail and extremely powerful straight-line winds. It was part of a strong system that had moved across the Great Lakes in the previous days. The storm arrived in Pittsburgh on the afternoon of January 9. Newspapers reported that the outside temperature fell from fifty-four degrees to forty degrees in under two hours. It came in quickly, and the winds escalated to forty miles an hour with occasional tornado-strength bursts while many people were on their lunch breaks.

The storm caused severe property damage in the downtown area and claimed the lives of fifteen people. More than fifty more were badly injured. Several buildings that were under construction collapsed. One was near the corner of Diamond and Wood Streets. When it fell, it also damaged the walls of the surrounding buildings. Many of the fatalities occurred when debris from the building crushed people working inside the neighboring structures or on the street below. Another building that came down was the Iron City Nut-Works on the corner of Forty-sixth and Hadfield Streets. A dozen other structures in Pittsburgh and Allegheny City were badly damaged. The Fort Pitt Foundry on Thirteenth Street was the scene of a tremendous amount of destruction. The roof of the South Side Market House also collapsed. One of the buildings

at the Westinghouse Air-Brake Company in Wilmerding shifted on its foundation and had to be evacuated. Roofs were blown off houses in McKeesport. Numerous telegraph and telephone lines went down. It was estimated at the time that the repairs would cost, in the city of Pittsburgh alone, over $165,000.

A GHOST IN THE COUNTY JAIL

It is not easy to frighten hardened murderers, but something scared them as they sat in their cells on murder's row in the Allegheny County jail. It was mid-September 1907, and the fourteen inmates demanded to be moved to a new location. The prisoners were unable to sleep and insisted that they were being haunted by the ghost of a former cellmate, W.A. Culp. Culp had been awaiting trial for the murder of his brother. Instead of facing a jury, he committed suicide in early September. After his death, the other prisoners reported that he was visiting them in their cells every night. Their complaints were authentic enough to convince the warden to move the murderers to cells in other parts of the prison.

MIRACULOUS WEEPING ICONS

Icons have long been a common feature in Eastern Orthodox Christianity and Catholicism (usually Eastern

Rite churches). They are usually a very colorful flat painting on wood depicting Jesus, Mary or the saints. The images are heavily loaded with symbolism in both depiction and color. Iconographers follow specific guidelines and traditions when they create the revered images. Icons have also been associated with miraculous happenings. Over the years several icons in western Pennsylvania have been known to "weep" oil or water with no apparent explanation. Weeping icons have been reported in the Orthodox churches since the eleventh century. The faithful take the seemingly supernatural weeping as a sign, and the location of the icons becomes a place of veneration and prayer.

Three icons began to weep in the spring of 1960. They were put on display at St. Mary's Orthodox Church in McKeesport. All three were icons of Mary. The weeping began on May 7, and by late July, only one of the three was still producing tears from its eyes. There were numerous witnesses to this occurrence, including bishops, reporters, chemists, church groups and priests from other denominations. None could find a scientific explanation for the phenomena. It is not clear how long the remaining icon continued to weep.

On August 18, 1988, an icon of the Holy Theotokos (Blessed Virgin Mary) began to weep at Holy Resurrection Orthodox Church in Belle Vernon. An oil-like substance flowed from the forehead, right hand and left shoulder of the icon. Later, two more streams of oil were present. The flow lasted for about three weeks. The pastor, Reverend John

Kluchko, carefully collected all of the oil by absorbing it with cotton balls. Once again, there seemed to be no logical explanation for the weeping. The icon attracted thousands of pilgrims, curious visitors and reporters. Kluchko kept the church open extra hours so that worshippers could pray in the presence of the icons.

Around that same time in 1988, nineteen icons began to weep at a Greek Orthodox summer camp, Camp Nazareth, located north of the city in Mercer County. The icons of Mary began weeping after a Supplecation Service to the Blessed Virgin Mary held on July 21. The next day, an icon located in cabin three began to produce tears. It had been blessed the day before. The "tears" produced a strong fragrance that smelled like flowers, and it filled the entire cabin. Soon other young people at the camp reported more weeping icons. Father John Chakos, a priest from Holy Cross Greek Orthodox Church in Mount Lebanon, was one of the witnesses. He collected some of the tears on cotton balls, which retained the strong fragrance. Eight priests, including Bishop Maximos, came to verify the phenomena. Father Chakos told the *Valley Independent*, "I believe it was a true miracle that happened for the children."

IS HE DEAD OR ISN'T HE?

On October 20, 1854, the *Daily Morning Post* had the sad duty of reporting the death of one of its employees. The

paper had received word that twenty-one-year-old David L. Fleming, one of its compositors, was killed on a trip to visit relatives in Phoenixville, Chester County. The details of his tragic death came via telegram from Philadelphia. Fleming had entered into an argument with another man named Truman. Truman apparently became so angry that he stabbed him in the heart. The *Post* article went on to describe Fleming as a young man of "temperate habits and exemplary conduct."

Luckily for Fleming, the reports of his death were untrue. Someone had apparently hoaxed the *Post*, and the young man was alive and well. On October 23, the paper ran a correction titled "The Murder of David L. Fleming Not True." It was never clear as to why the false report was sent to the paper.

BALLOONS STRUCK BY LIGHTNING

A tragedy struck a national hot air balloon race at the end of May 1928 as it floated above the city of Pittsburgh. Many of the participants were members of the U.S. Army flying the army's balloons. Fourteen balloons were in the race. After they passed over Pittsburgh, there was only one left. The balloonists were experiencing bad weather by the time they reached Allegheny County. A storm developed with severe lightning; winds and heavy rain forced some to the ground. Army No. 3, piloted by Lieutenant Paul Evert,

was struck by lightning when it was one thousand feet in the air. It caught fire and plunged to the ground, killing Evert. Surprisingly, his aide survived the fall. Goodyear V, piloted by Ward T. Van Orman and his aide Walter Morton, was also struck by a bolt of lightning. It, too, plummeted to the ground. Morton's skull was fractured upon impact, but Van Orman only suffered a broken leg. Lightning struck a third balloon, the City of Cleveland, burning and shocking aide James Cooper. He and the pilot both survived. The only balloon that finished the race in Weems, Virginia, was Army No. 1.

HOODOO IN THE HILL

The practice of African American folk medicine and sympathetic magic known as hoodoo or conjure is not often linked with Pittsburgh. Usually it is associated with the rural South or sometimes northern cities like Philadelphia or Chicago that had large and densely packed black populations. After the great migrations of the early twentieth century, when large numbers of blacks left the South to settle in northern cities, the practice of hoodoo followed with them. It also came to Pittsburgh, though outsiders paid little attention to the folk tradition here. One of the few accounts of the practice came as a result of the Federal Writers' Project during the Great Depression. The folkways of the black population of

the Hill District were recorded, though not entirely understood, by Abram T. Hall. He wrote a chapter for a book that was not published at the time called *The Negro in Pittsburgh*. The book was finally reedited by Laurence Glasco and published by the University of Pittsburgh Press in 2004. Though only a few pages are dedicated to hoodoo and conjure, it is enough to show that the tradition was alive and well here.

Many people make the mistake of treating voodoo and hoodoo as the same thing. Where hoodoo/conjure is simply a folk medicinal/magical practice, similar to Pennsylvania Dutch powwowing, voodoo combines African religious traditions of spirit possession and worship of multiple deities with elements of Catholicism. Both practices have

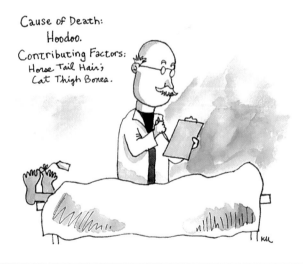

roots in African tradition, and their similar names can cause confusion for nonpractitioners. It is likely that most of what Hall encountered was hoodoo, but he does describe a few voodoo-related practices. Hall noted that there were several shops that sold hoodoo/voodoo-related goods and ingredients in the Hill District.

In his writing, Hall describes the creation and sale of one of the most common hoodoo talismans, the mojo hand, also known as a mojo bag, root bag or *gris gris* bag. Hall describes them as "voodoo bags" or "lucky bags." Traditionally the bags, often made of red or gray flannel, are three inches long by two inches wide or two inches long by one inch wide. The bags are filled with ritualized objects such as silver coins, specific roots, oils, lodestones, a rabbit's foot, animal teeth, etc., depending on the purpose of the charm. Some are created to provide luck in love or gambling, while others are made to ward off harm or evil spirits. The bag is usually worn around the neck and concealed beneath clothing.

Some of the practices were not just for medicinal reasons or luck. Hall details the practice of "fixing" an enemy. One must dig up dirt from the east corner of a cemetery and say, "I am digging this dirt for the Father, the Son, and the Holy Spirit." Then it is mixed with red pepper and salt and placed either under the offending party's mattress or his/her front steps. Hall noted that the enemy will "be tormented for the rest of his life, and will never be able to face you." Another curse that was used in the Hill was the "withering conjure." It required finely cut hairs from the tail of a black

horse and two ground thigh bones from a black cat. When mixed together they are placed in an enemy's food, which will cause them to contract withering fever.

Most hoodoo charms and practices were for healing minor ailments and protection, and others were just superstitions. For example, a potato rubbed on a wart and then burned or thrown in the river will make the wart go away. Crooked and twisted objects were considered lucky, as were certain numbers and days of the week. It was also believed that things should be done in threes to prevent bad luck. Hall uses the example of breaking a dinner plate. Bad luck will result unless two more are broken. As for voodoo, Hall noted that initiation into the voodoo cult or "the Order of the Serpent" takes place on St. John's Eve (June 23). It was accompanied by music and dancing, as well as ritual incantations. His brief description of the ceremony resembles other St. John's Eve rites described by another New Deal–era writer, Robert Tallant, who wrote *Voodoo in New Orleans*.

Like many other folk traditions, especially in northern urban areas, hoodoo slowly faded from the scene with the rise of a more uniform mass culture in America after World War II. Some of its tenants survive as family traditions and in underground practice, but it is not as uniformly practiced as it was in the late nineteenth and early twentieth centuries.

Attacked by a Lion

On one late summer afternoon in 1907, visitors to Pittsburgh's Luna Park watched a show that they would never forget. Luna Park was one of the city's early trolley parks, a forerunner of today's amusement parks. It was bounded by Baum Boulevard, Centre Avenue and North Craig Street. On August 27, a lion that was caged in the park somehow escaped. The Daughters of the American Revolution were having a picnic in the park that day, and the park was crowded with women and children. It did not take the lion long to select one of the women as his prey.

Fifty-five-year-old Anna Houck spotted the lion emerging from behind a building. It let out a loud roar and then charged toward her. Instead of running to save herself, Mrs. Houck pushed several children to safety. The lion knocked the woman to the ground and began to tear at her clothes and flesh as she screamed. Park-goers looked on in terror, afraid to approach the lion to help. The chief of the park police, W.A. Downing, arrived quickly and fired all six rounds of his revolver into the animal. It remained on its feet, roaring defiantly and occasionally picking Mrs. Houck up in his mouth. Men who were trying their luck at the park shooting range came running to help. They fired at the ground near the lion but were afraid they would strike Houck. More police arrived and faced the same problem. The lion stood over Houck for fifteen minutes until Officer George Sheridan fired a shot from the roof of

the bandstand that struck the lion. He jumped down from the roof and shot the animal again.

Sheridan moved in closer, and the lion backed up momentarily. The officer was able to pick up Mrs. Houck with one arm. As he started to move away, the lion charged him. The officer raised his gun and fired again, hitting the lion in the head. The enraged beast showed no sign of slowing down, so Sheridan fired again. Even with another bullet in it, the lion continued to charge. Sheridan fired a third shot with the lion only feet away, and finally it went down. The rest of the men continued to fire at the corpse until it was—as the newspaper described it—turned into a sieve. Mrs. Houck was battered and in shock but survived the attack thanks to Sheridan's bravery.

A PITTSBURGH WOMAN SPONTANEOUSLY COMBUSTS

Strangely enough, a different Mrs. Houck was involved in a bizarre incident in Pittsburgh the same year. Unlike the victim of the lion attack, the other Mrs. Houck did not survive. On January 28, 1907, Albert Houck discovered the body of his wife on a table. She was, in his words, "burned to a crisp." The strange part was that the table was not burned, nor was there apparently any other fire damage in their residence. No one could explain why only she burned. Later, investigators described it as a case of spontaneous human combustion—a phenomenon that is not accepted

by mainstream science. When the combustion happens, the victim is reduced to charred cinders and ashes by a fire that seemingly starts in or on them. The surrounding room and furniture usually have no or very little damage. It is not clear if the two unfortunate Mrs. Houcks were related.

PITTSBURGH POLICE CRACK DOWN ON FORTUNETELLERS—IN 1859

In June 1859, Pittsburgh public officials decided to crack down on local fortunetellers, whom they viewed as "common cheats." One particular fortuneteller, Madame Willis (aka Madame Morrow), inspired the police action. She had apparently told some young ladies who came to visit her that some of their friends were about to die. This caused a panic among the ladies, who could not sleep or concentrate on anything else. A young man, who learned of the young ladies' distress, gathered some information and appeared before Mayor Weaver to ask for help.

Soon police were dispatched to the three-story home of Madame Willis on Second Street. When they entered, the maid insisted that Willis was not home. However, one of the officers caught a glimpse of something moving in the other room. They insisted that they would not leave until the madame came with them. Reluctantly, Willis agreed, but only if they would give her an hour to prepare. As the officers waited, thirteen people came to have their fortunes' told,

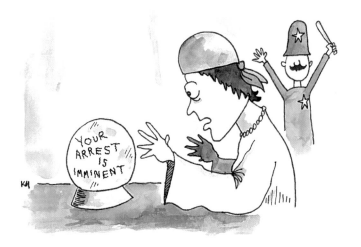

only to be turned away. The authorities also searched the home, finding books on palmistry, astrology, fortunetelling, dream interpretation and others too "questionable" to mention in the newspaper. There were numerous posters describing Madame Willis's fortunetelling talents under a variety of aliases. Counterfeit coins were also discovered in a drawer along with $300 in cash and expensive jewelry.

It was discovered that the madame's real name was Mrs. Elizabeth Morris. Her husband's name was Isaac, but he was not there when she was arrested. The police brought the woman before the mayor, and she admitted that she was a fraud. He fined her twenty-five dollars and gave her twenty-four hours to leave the city, which she presumably did. The police continued to search for other fortunetellers who were taking advantage of the public.

A FORERUNNER OF THE NEWSPAPER HOROSCOPE

Only one year after Pittsburgh police cracked down on fortunetellers, a newspaper in Beaver County ran what could be described as a forerunner of the daily newspaper horoscope. Newspaper horoscopes became common in the twentieth century after the rise of broad public interest in astrology and the occult in general. They are not usually tied to actual astrology but are written merely for entertainment. This early version appeared in the *Beaver Weekly Argus* on May 30, 1860. It was simply titled "Fortune Telling," and the resemblances to later horoscopes are obvious. It did not reference signs but rather months of birth. It read as follows:

> January—*He that is born in this month will be laborious, and a lover of good wine, but very subject to infidelity, yet he will be complaisant, and withal a fine singer. The lady that is born in this month will be a pretty, prudent housewife, rather melancholy, but yet good tempered.*
>
> February—*The man born in this month will love money much, but ladies mere; he will be stingy at home, but prodigal abroad. The lady will be a humane and affectionate mother.*
>
> March—*The man born in this month will be rather handsome; he will be honest and prudent; he will be poor. The lady will be jealous, passionate, and a chatterbox.*

April—*The man who has the misfortune to be born in this month will be subject to maladies; but will travel to his disadvantage, for he will marry a rich heiress, who will make—what no doubt you understand. The lady of this month will be tall and stout, with agreeable wit and great talk.*

May—*The man born in this month will be handsome and amiable; he will make his wife happy. The lady will be equally blessed in every respect.*

June—*The man born in this month will be of small stature, and passionately fond of children. The lady will be a personage fond of coffee, she will marry young.*

July—*The man will be fat and suffer death for the wicked woman he loves. The female of this month will be passably handsome, with a sharp nose and a fine bust, she will be of rather sulky temper.*

August—*The man will be ambitious and courageous, he will have two wives. The lady will be amiable and twice married, but her second husband will cause her to regret her first.*

September—*He who is born in this month will be strong and prudent, but will be too easy with his wife, who will give him great uneasiness. The lady will be round faced and fair haired, witty, discreet, and loved by her friends.*

October—*The man of this month will have a handsome face and florid complexion; he will be wicked in his youth and always inconsistent. He will*

promise one thing and do another, and remain poor. The lady will be pretty, a little fond of talking, have two husbands, who will die of grief; she will best know why.

November—*The man born in this month will have a fine face and be a gay deceiver. The lady of this month will be large, liberal and full of novelty.*

December—*The man born in this month will be a good sort of person, though passionate. He will devote himself to the army and be beloved by his wife. The lady will be amiable and handsome, with a good voice and well proportioned body; she will be twice married, remain poor, but continues honest.*

While this horoscope and later ones are meant to entertain, I think that this one may be accurate because I was born in May.

CHARLES TAZE RUSSELL AND THE PYRAMID MONUMENT

Charles Taze Russell (1852–1916) was a restorationist minister credited with founding the Jehovah's Witnesses. He was also born and buried in Pittsburgh. In 1879, he started the magazine *Zion's Watch Tower and Herald of Christ's Presence* in Allegheny City. Russell's story is familiar to those who study America's religious history, and the movement

that he started continues today. However, many people are not familiar with his unique grave.

Anyone who has traveled along Cemetery Lane in Ross Township has probably seen the grave, even if they did not realize its significance. At the sharp bend in the road, a small pyramid can be seen on the hillside among the graves. The pyramid is actually a monument to Russell and sits near his gravestone in Rosemont United Cemetery. It was erected several years after his death by some friends and associates. The symbol of the pyramid was used by Russell frequently in his extensive writings and speeches.

DON'T EAT THE INFECTED RABBITS!

On December 20, 1930, a burglar broke into the laboratory at St. Margaret's Hospital. After the lab was ransacked, the trespasser made off with four rabbits that were in cages. It was assumed by authorities that whoever took them was planning on eating them. Animal theft was not uncommon during the Great Depression when individuals ran out of options for finding food. The problem in this case was that the rabbits were in a medical lab and were infected with deadly diseases. Doctors warned police that if anyone ate the rabbits, there was a very good chance that they would die. A notice was put in the paper to try to warn whoever had taken the animals. It does not appear that the thief was ever found.

Strangely enough, a similar incident happened in February 1932 at the Charleroi–Monessen Hospital. This time, the thief took not only an infected rabbit but also an infected sheep. The sheep had been inoculated with a variety of diseases during its yearlong stay at the hospital lab. Once again, authorities posted warnings in the paper fearing that a destitute family might try to consume the sheep or rabbit. The thief was not apprehended in this case either, and the animals were never returned.

DID JACK THE RIPPER LIVE IN PITTSBURGH?

The murders committed by the serial killer known as Jack the Ripper are probably the most well-known crimes carried out by a lone individual in modern history. In the fall of 1888, the Ripper killed at least five prostitutes in the Whitechapel neighborhood in the east end of London. The gruesome nature of the killings, with their escalating mutilations, captured the attention of the press and the public. The fact that the police failed to catch the killer has made it the ultimate unsolved crime, and the identity of the Ripper has been the subject of speculation and debate ever since. One of those many suspects briefly captured the attention of authorities in London at the time of the killings. He was detained for another offense but was released and slipped out of the country. Police dismissed him as the culprit. The suspect happened to be an

American quack doctor named Francis Tumblety. When Tumblety returned to America after being released from custody in London, he was watched closely. The *New York Times* even kept the public informed of his whereabouts before he disappeared again. Strangely enough, he was forgotten by "Ripperologists" for decades. Recent research has interjected him as a possible suspect again, and there has been much interest in his life and whereabouts. He also happened to live in Pittsburgh and practice medicine here for a couple of years in the 1860s.

Tumblety was born in 1833 in either Ireland or Canada. By the 1840s, his family had moved to Rochester, New York, where his neighbors quickly developed a bad opinion of the young man. When he was young, he worked in a drugstore with a questionable reputation and was known to peddle pornographic literature to passengers on the canalboats. In the 1850s, he started calling himself a doctor and became successful selling patent medicines and quack cures. He was also rumored to have been an abortionist. During the Civil War, he pretended to be a well-connected Union army surgeon and took to wearing unearned military uniforms. He was even briefly arrested as a potential conspirator in the Lincoln assassination, but it was merely a case of mistaken identity. Tumblety was known to be a homosexual or bisexual and had reportedly expressed feelings of anger and hatred toward women—a characteristic that is often brought up in discussions of the Ripper's motives. The "doctor" moved

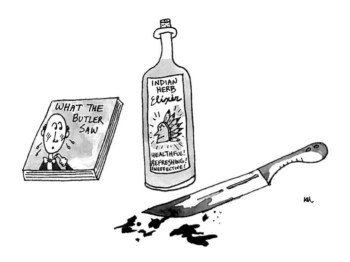

around frequently, which was common for charlatan doctors of the era.

By October 1866, Tumblety had decided to set up his practice, if you can call it that, in Pittsburgh. He ran two advertisements in the *Pittsburgh Commercial* on the twenty-fourth of that month. Tumblety did not use his name but described himself as an "Indian Herb Doctor." The ads listed seventeen ailments that he had successfully cured. Two addresses were given to reach the doctor. He had an office at 194 Liberty Avenue and could also see patients at his room (no. 99) in the Merchant's Hotel. As time went on, he ran more advertisements that included testimonials and the names of 144 satisfied patients. The majority (70 percent)

of Tumblety's patients seemed to be working-class men, probably because of his low fees. Tumblety also appeared in the *Directory of Pittsburgh and Allegheny Cities* in the 1867–68 edition at the same addresses listed in the ads. Though not many hard facts are known about his time in Pittsburgh, Tumblety seems to have had some degree of success.

Several apocryphal stories about the quack doctor circulated after he left, possibly inspired by the later accusations against him. One such story recalls a time when the doctor was thrown from his horse. He had apparently hit his head and was not conscious, perhaps comatose. Bystanders believed him to be dead. His body was laid out for three days, since no relatives could be found, and was then prepared for burial. The undertaker had trouble fitting Tumblety—who was five-foot-ten or five-foot-eleven and considered tall for the time—into the coffins that were available. He decided to cut off part of his legs to make him fit, which was not necessarily an unusual practice. As the undertaker started to draw the saw across Tumblety's legs, the doctor sprang to life (and probably almost scared the undertaker to death).

Other stories relate to the doctor's well-known perversions. He was allegedly arrested at one point because he attempted to "pick up" two young men on a street corner. The charges were supposedly dropped because several of his patients testified on his behalf. There is also a story about why the doctor suddenly left town. Apparently two female patients accused the doctor of taking liberties with them. He did not

stick around to answer to the accusations. A connected story, which is most likely untrue, is that jars containing human uteri were discovered in his office after he left.

Tumblety's last ad ran on January 11, 1868. It is not clear when he actually left, but he was known to be staying in a New York hotel in 1869 and had some printing done in New York two years later. Strangely, though, a Francis Tumblety, physician, appears in the Pittsburgh directory for 1872–73. His address is listed at that time as 188 Liberty Avenue, just a few doors down from before. This is unusual because the building at 188 Liberty was the Pittsburgh Savings Bank, and it is unlikely that apartments were located in the same building. Perhaps he was renting office space, but it is clear that most of his time was spent elsewhere.

Years later, while living in England, Tumblety was briefly suspected of carrying out the Ripper murders. Criminal profiling was in its infancy, and the police were looking for a man who had some medical knowledge and was socially abnormal. The police also recognized that there was a sexual element to the crimes. Tumblety happened to be arrested around the time of the killings for gross indecency (a charge frequently used to arrest men engaging in homosexual acts) and was held briefly. It was concluded that he was not the man they were looking for, and Scotland Yard was not very concerned after he fled the country. He eventually died in 1903 in St. Louis and was buried in Rochester. There are still researchers who believe that Tumblety could have been the Ripper.

THE PITTSBURGH MAFIA'S GREATEST HITS

Prohibition brought organized crime to Pittsburgh as it had to other cities during the 1920s. Several factions struggled for dominance in southwestern Pennsylvania, and the most aggressive ones were led by Sicilian families who had previously been associated with the mafia in southern Italy. Some members of mafia families had fled to the United States after Mussolini took power in 1922 and cracked down on organized crime. The ban on alcohol provided the perfect opportunity for the mob to make a profit. Of course, the competition over the illegal liquor trade also brought violence. It is estimated that there were at least two hundred associated killings in Allegheny County between 1926 and 1933. The bosses themselves were not immune.

One of the first bosses to meet a violent end was Stefano Monastero. Monastero, who was born in 1889, had been operating clandestine liquor warehouses since 1925. He was suspected of bombing rival warehouses in the late'20s. His men may have also had a hand in gunning down one of his competitors, Luigi "Big Gorilla" Lamendola, in May 1927. Monastero's reign ended as he got out of his car in front of St. John's General Hospital on August 6, 1929. Gunmen leapt from their hiding places and opened fire with shotguns. The barrage was not survivable. Police believed that another of Monastero's rivals, Joe "the Ghost" Pangallo, arranged the murder, but it could never be proven.

After Monastero's death, Joseph Siragusa rose to power. Known as the "Yeast Baron," Siragusa dominated much of the manufacture and trade of illegal alcohol in Allegheny County. His brief time as boss ended on September 13, 1931. Siragusa became a victim of "Lucky" Luciano's purge of the American mafia. Three gunmen from New York entered his home in Squirrel Hill and found him preparing to shave in the basement. As he tried to flee, they shot him five times. When he fell, he knocked two holy cards and a rosary off of the banister. They fell on top of his lifeless corpse. His pet parrot, with the original name of Polly, was found in his nearby cage repeating the words "Poor Joe!" over and over again.

John Bazzano Sr., a theater manager from Mount Lebanon, stepped in to take over and expand the operation. His major rivals were Neapolitan racketeers from Wilmerding. The Volpe brothers, sometimes known as the Volpe Eight, were looking to aggressively expand their own bootlegging operations. The brothers flagrantly dominated politics in the Turtle Creek Valley and were known to flaunt their wealth and success. To stop their expansion, Bazzano ordered a hit on the brothers. First, he gained their trust by offering a partnership. He convinced the brothers to trust him and offered his Roma Coffee Shop on Wylie Avenue as a shared base of operations. On the morning of July 29, 1932, hit men pulled up outside the shop while the Volpe brothers ate breakfast. They fired a barrage of bullets into the building. John Volpe, who was standing outside,

received four bullet wounds and died. Two of his brothers, Arthur and James, were killed inside at the counter. The other five brothers survived.

Over fifty thousand people came to pay their respects to the deceased Volpe brothers, including police officers and politicians. Two of the surviving brothers approached allies in New York and the newly formed La Cosa Nostra Commission for help in extracting revenge. The commission sided with the brothers and a trap was set. Bazzano was invited to a dinner with numerous other mafia leaders from around the country. At the dinner, Bazzano received at least twenty-two and as many as twenty-seven ice pick wounds, presumably delivered by the other bosses. On August 8, his body was discovered on a street in Brooklyn, New York. After his death, local mafia conflicts became more infrequent and much less dramatic.

WOMAN FOILS ROBBERY BY SWALLOWING HER DIAMONDS

On May 19, 1925, a Mrs. Mazur of Springdale was riding in the back of a car driven by Charles Brown, described as her escort. (When your driver is named Charlie Brown, you know bad luck is coming your way.) It was late in the evening, and the pair was traveling down Bouquet Road. Suddenly, two armed men with red handkerchiefs over their faces stepped into the road and demanded that the car stop.

Brown decided to accelerate instead and had almost cleared the bandits when one managed to jump onto the running board. He shot Brown in the arm and brought the car to a halt. The bandits took his watch and the forty-two dollars in is wallet. While they were taking Brown's money, Mrs. Mazur quickly removed her most expensive jewelry—a set of diamond earrings—put them in her mouth, and swallowed them. Before the bandits could do anything else, headlights began to approach from the opposite direction. The bandits fled, and Mrs. Mazur retained all of her valuables. Luckily, the newspapers spared us the details of the diamonds' recovery.

BLACK HELICOPTERS INVADE PITTSBURGH

In the late evening and early morning hours of June 3 and 4, 1996, Pittsburghers were startled out of their sleep by the sound of an aerial invasion. Mysterious black helicopters flew low over homes and buildings all along the three rivers. Gunfire and explosions were heard echoing in the Monongahela River Valley. Soldiers were seen sliding down ropes from the helicopters onto rooftops in areas such as Braddock and McKeesport. Some helicopters were so close to the ground and rooftops that some people claimed they could have reached up and touched them with a broomstick. Police dispatchers and 911 received over one hundred frantic phone calls from concerned residents.

Many feared that a coup or military invasion was taking place. A few thought that the commotion was related to UFOs. One pregnant woman was so frightened that she went into labor. Radio talk shows were flooded with calls from people who were watching the invasion. Reports continued all night.

The mid-1990s saw a surge in conspiracy theories about a secret government or United Nations takeover of the United States and a suspension of the Constitution. Some opponents of the Clinton administration believed that the president himself (who was surrounded by numerous conspiracy theories and scandals) was planning to seize dictatorial control using marshal law and FEMA (the Federal Emergency Management Administration). Unmarked black helicopters were a key part of that conspiracy. They were to serve as the transports and attack vehicles for the troops, possibly foreign, of the secret government when they seized power. These fears were fueled by the highly publicized incidents at Ruby Ridge and Waco. Other rumors circulated that concentration camps were being secretly established across the country to imprison United States citizens who resisted. One of these camps was allegedly located near the Allegheny National Forest. Some of these conspiracies were discussed on local radio shows, including the *Quinn in the Morning* show that was broadcast from WRRK in Braddock.

It is easy to see how the helicopters could cause panic in such a context. By the next morning, however, it became

clear that the frightening invasion was actually a poorly planned and communicated military training exercise. In total, it involved at least nine Blackhawk helicopters and two hundred troops from Fort Bragg. The purpose of the exercise was to practice nighttime urban infiltration, and it was coordinated with some local law enforcement. It used a combination of actual controlled explosions and recorded bombs and gunfire. Unfortunately the military failed to warn city officials and alert the press. The military did send out warnings in some of the immediate neighborhoods, but only a few hours before

the exercise. Many residents never received the warnings. Public outcry against the exercise was so great that the rest of the scheduled nighttime exercises were canceled. Some suspected that the location of the exercise was no accident and that it was selected because of the anti-Clinton stance of the *Quinn in the Morning* show.

Three years later, black helicopters were spotted again in western Pennsylvania skies. On March 18, 1999, dozens of black helicopters were reported over Pittsburgh and to the west, all the way to the West Virginia border. Most of the sightings occurred between 3:00 and 3:30 a.m. Once again, they were flying low and seemed to be traveling south to north. Again the helicopters were reported to be part of a military exercise, though slightly less disruptive than the previous one. Black helicopters were reported in numerous locations around the country that March.

BOOTLEGGERS LEAVE PREACHERS IN THE DARK

Prohibition may have been the law in the 1920s, but it was a law that was frequently broken. The pastors and preachers in Carnegie decided that they were going to try to do something about that. The pastors of five different Protestant churches agreed to each preach the same sermon on the same night to each of their congregations. The purpose of the "dry" sermons was to emphasize the moral evils of alcohol and the necessity of following the

Prohibition law. It was decided that the sermons would be preached in early January 1921.

Apparently, the pastors did not keep their plans secret enough. Someone became aware of synchronistic sermons—someone who did not agree with the message. The press later labeled the culprits as bootleggers, but it may very well have just been people who were opposed to Prohibition. They too had a plan to be at all the churches, but for a different reason. Just as the pastors of all five churches (Baptist, Presbyterian, United Presbyterian, Methodist Episcopal and Primitive Methodist) began their sermons, the lights went out. When church members investigated the problem, they discovered that the main switches had been thrown and the power lines cut on all five buildings. The preachers all called one another and discovered that their individual churches were not the only targets. It was decided to continue the sermons in the dark. By that time, however, most of the people in the congregations had decided to go home.

A FALL FROM THE POINT BRIDGE

The first Point Bridge was finished in 1877. The pressure was on during construction to complete the project as quickly as possible. This meant that safety was not always a priority. On December 3, 1876, a worker was joining cables on a small platform suspended ninety feet above the Monongahela River. Somehow he slipped and fell off. A

rope was hanging from the platform all the way down to only a few feet above the water. As the man fell head over heels through the air, he desperately grasped at the rope. Finally, about twenty feet above the river he got hold of the rope with both hands. Unfortunately his hands slid another fifteen feet down the rope until he was able to stop with his feet just inches above the water. Those who were witnessing the event on the banks of the river cheered when they saw him stop. The man then proceeded to climb back up the rope to the platform. His hands were bleeding from sliding on the rope, but he was otherwise unharmed.

MUSEUM KEEPS STOLEN IDOL

That was the headline in the *New York Times* in February 1906. Luckily, it was not as bad as it sounded. A few years previously, the Carnegie Museum of Pittsburgh purchased what the paper described as a "Mexican idol" for its collection. It was unaware that the artifact had been stolen from the private museum of the governor of Veracruz. The only reason that the Carnegie Museum learned that it had purchased stolen property was because a Pittsburgher who frequented the Carnegie happened to visit Governor Dehesa's personal museum on a trip to Mexico. The governor told the man the story of the theft and showed him a picture of the artifact. The Pittsburgh man recognized it immediately, and they contacted the museum director, Dr.

Holland. Once it was confirmed that the artifact was indeed the same one, Holland offered to return it. Governor Dehesa decided that the artifact should be shared with the public and allowed the museum to keep it.

BONES OF AN ANCIENT GIANT

Speaking of Dr. Holland, in 1921 he was involved in the excavation of one of the many Indian mounds that once dotted the landscape of western Pennsylvania. The mounds were built centuries ago by a branch of the Adena-Hopewell people who used them as burial sites. The particular mound that Dr. Holland was investigating that year was located in Greensburg. The mound, which was twelve feet high and over one hundred feet long, yielded an interesting find. The archaeologists uncovered the skeleton of a very tall man whom they estimated to be between eight and nine feet tall. Another normal-sized body was discovered at the dig as well. It was partially mummified, and the archaeologists estimated that it was at least four thousand years old. The age of the mummified corpse was, most likely, grossly overestimated.

PLANE CRASHES ON BAUM BOULEVARD

Drivers on Baum Boulevard and Centre Avenue in Pittsburgh had to worry about more than traffic lights

and pedestrians one winter day in 1934. They had to avoid hitting a plane and its pilot. On January 4, a single-passenger plane flown by twenty-one-year-old George Yeske had caught fire above the city. Unable to extinguish the fire, Yeske aimed his plane at the road and then jumped with his parachute. As the airplane plunged toward the ground, drivers and pedestrians scrambled to get out of the way. The plane slammed into a telephone pole, which in turn fell over onto the Auto Sales and Service Company at 5255 Baum Boulevard. A few people received minor injuries from flying glass and debris, but no one was seriously hurt. Hundreds of people watched as the pilot came down slowly in his parachute. The parachute eventually snagged on a telephone pole on Centre Avenue, but Yeske made it to the ground with only minor injuries. He landed two hundred feet from the Homeopathic Hospital.

THE TALKING DOG

Charles Fort, one of the first modern chroniclers of the unusual and unexplained, recorded a very strange incident that allegedly happened in Pittsburgh in 1908. He was dismissive of the story but nonetheless devoted several pages of discussion to it in his book *Wild Talents*. Police had been patrolling Lincoln Avenue because there had been a series of robberies and break-ins on the street. Early on the morning of July 26, some detectives

were walking the street, surveying the neighborhood for anything suspicious. As they moved down the street, a large black dog passed them. To the detectives' amazement, it paused and said "good morning." Then it disappeared before their eyes in a wisp of green vapor. Fort did not record the officers' reactions but cited an article in the *New York World* on July 29 of the same year as his source. In British and American folklore, supernatural black dogs are often associated with the devil.

BANK ROBBER AND ESCAPE ARTIST

Joseph Pluymart was one of Pittsburgh's first bank robbers. He was also the hardest to hold in captivity. On April 6, 1818, Pluymart and Herman Emmons broke into the Farmers and Mechanics Bank of Pittsburgh after hours. Pluymart had acquired copies of the vault keys through some unknown means. The pair made off with $100,000 in bank notes and $3,000 worth of gold and silver. They also stole a gold medallion that Congress had presented to Revolutionary War hero General Daniel Morgan in 1790. It was in the bank because it now belonged to bank cashier Morgan Neville, who happened to be his grandson.

Authorities received tips as to the identities of the two men, both known to have gambling debts. By April 17, the bank posted a $1,000 reward for the return of the men and the money. On April 24, it was raised to

$3,000. It was discovered that Pluymart and Emmons had purchased a boat in Elizabeth just before the robbery that had a concealed compartment on the bottom. The boat would allow them to escape downriver while hiding their stolen loot. By the end of April, the two men had been captured in Ohio and were being held in a Cincinnati jail. While the two states were debating extradition details, both men managed to escape. The authorities caught up to Emmons and wounded him during the recapture. Pluymart slipped away.

After Emmons was brought back to Pittsburgh, he agreed to show the bank where the money had been hidden if he received no jail time. He led authorities thirty-seven miles downriver to the hiding place. Everything was recovered except for $2,700 and General Morgan's medallion. In mid-June, Pluymart was apprehended near the Canadian border in New York. He was carrying $5,000 in notes and gold. Two days after his arrest, he escaped again. A search party was formed, and a $50 reward was offered for his recapture. Officers caught him about fifteen miles away and brought him back. One of the local magistrates called him "a consummate villain." Pluymart was transported back to Pittsburgh for trial. After his conviction, he was given a three-year sentence. He did not serve all of it because—as you probably guessed—he escaped again. Eventually, Governor John Andrew Schulze decided to break the capture-escape cycle and save everyone involved the hassle of chasing Pluymart by granting him a full pardon.

THE KLAN INVADES CARNEGIE
(OR AT LEAST IT TRIED)!

The organization known as the Ku Klux Klan first appeared in western Pennsylvania in 1921. By 1924, it had around 125,000 members in the region. Many white Protestants flocked to the Klan because of the ethnic and economic changes that were occurring in the area in the previous decades. The influx of thousands of non–English speaking immigrants who were Catholic, Jewish and Orthodox was seen as a threat to many whose families had long been in America. At the same time, many blacks had left the South to take industrial jobs in Pittsburgh and surrounding communities. Industrial production in western Pennsylvania was slowing in the 1920s, and these newcomers were unwanted competition for a shrinking number of jobs. The Ku Klux Klan advocated an anti-Catholic, anti-Semitic, anti-immigrant and anti-black view of America. In their opinion, immigrants and blacks were linked to vice, alcohol abuse and other moral problems. The Klan viewed itself as having the moral authority to address these issues if the government was unwilling to do so. Though the Klan had a brief surge in popularity, by the end of the decade it was down to a few thousand members. It did, however, engage in vigilante actions and take violent measures on some occasions throughout the '20s. It also engaged in very public celebrations and held parades and events. Sometimes these events would provoke a response

from those who did not agree with their message. One of the most significant of such incidents occurred in the town of Carnegie in 1923.

The Klan decided to hold a large parade and celebration in Carnegie on August 23 of that year. The purpose was to initiate new members into the group and also to recruit more members. Carnegie was chosen because of its mixed ethnic and religious population. The day of the event, Klansmen assembled just outside of town at Forsythe's Hill in Scott Township. From there they planned to march into town. Estimates of their numbers range from ten thousand to twenty-five thousand. While they waited, speeches were given, fireworks were set off and several prominent Klansman from around the country had arrived. Some members of the Klan who were clearly wearing pistols on their belts started to direct traffic in town so that other members could get through. Needless to say, this caused some resentment. The police and the mayor informed the Klan that they would not be permitted to march through Carnegie because of the possibility that their presence could cause violence.

The leaders of the Klan discussed what to do next. It was decided that they would march into town anyway. By ten thirty in the evening, five thousand Klan members were on their way down to Carnegie. The procession was led by a carful of women who carried an electrically lighted cross. As the procession neared the Pan-Handle Railway Bridge, they discovered that it had been blocked by trucks and cars. They altered their course and decided to cross the Glendale

Bridge instead. One resident of Carnegie attempted to block their path with his car, but he was unsuccessful. The procession made it to Third Street where they first encountered police. They also encountered a crowd of at least one thousand angry Carnegie residents. The handful of officers could not control the crowd or convince the Klan to leave. Stones and bricks were hurled at the Klansmen as they attempted to move forward. Some Klansmen were knocked to the ground. The crowd tore off their hoods and robes. Someone began firing a gun as chaos broke loose. One of the Klan's new recruits, Thomas Abbot, was shot in the head and killed. Many abandoned their hoods and Klan trappings in an attempt to flee. Wounded and beaten Klansmen were dragged out of town and back up the hill. The police again demanded that the Klan leave to prevent further violence, and this time they listened. Back on the hill, some members wanted to arm themselves and return to town for revenge. Many of the leaders, however, chose to leave before the police could interrogate them.

The Klan ultimately used the riot and the death of Abbot as propaganda. Only one man was charged in the murder. Patrick McDermott was put on trial in November 1924 and was acquitted. Several of the armed Klansman who had been directing traffic in Carnegie the day of the riot were arrested and fined $10 each. The Klan leaders set up a fund to collect money for Abbot's widow and children. Allegedly, over $21,000 was raised, and the local Klan leaders ended up keeping most of it for themselves.

STRIPPED BY A STREETCAR

On October 30, 1889, an elderly woman had an unfortunate accident while exiting a streetcar. She was the last person off the car at the corner of Penn Avenue and Seventh Street. Somehow, her dress became snagged on a piece of the railing that had worked its way loose. The operator did not see that the woman was still caught, and the streetcar began moving again. The good news was that she was only dragged a few yards and was relatively uninjured. The bad news was that the reason she was able to get free of the moving car was that her dress was completely ripped off of her body, leaving her rather embarrassed.

THE STEAMBOAT *CUTTER* EXPLODES

In early March 1843, the midsized steamboat *Cutter* was loaded with passengers and cargo and was ready to leave the Mon wharf. It was a new steamer, built in Cincinnati, and its voyage upriver to Pittsburgh had been only its third excursion since construction. It was now preparing to head back downriver, but it would never complete the trip. Just as the boat reached the middle of the river, a strong wind came up. The wind pushed the *Cutter* in a starboard direction and caused water to enter the starboard boiler. The boiler then exploded and collapsed the flue, knocking several people overboard. One of

the boat's engineers was mutilated beyond recognition and killed. Another engineer, a fireman and a female passenger were severely burned. Five of those who were thrown overboard drowned, and several other passengers and crew on the boat received minor burns.

It was discovered after the accident that all the flues and boilers had been inspected before leaving the wharf. But it was also discovered that they were much older than the rest of the boat. The expensive boilers had been taken from another steamer, the *Richmond*, to save money. One of the surviving crew members blamed the accident on the penny-pinching owners and the government inspectors who failed to properly do their jobs.

LEWIS, CLARK, A DRUNKEN BOAT BUILDER AND AN ACCIDENTAL SHOOTING

Captain Meriwether Lewis was stationed at Fort Fayette in Pittsburgh in March 1801 when he received word that his old neighbor-turned-president of the United States, Thomas Jefferson, wanted to meet with him. Lewis traveled to Washington where Jefferson gave him the assignment of exploring the unsettled American West. Lewis would lead the Corps of Discovery through the Louisiana territory and beyond. Both men agreed that Pittsburgh, the original "Gateway to the West," would serve as the expedition's starting point and supply base.

Before returning to Pittsburgh, Lewis wrote to his old friend Captain William Clark, who was now retired and living on the frontier in Kentucky, and invited Clark to join him on the expedition. Lewis also commissioned the construction of a keelboat in Pittsburgh for $400 and ordered various other supplies to be prepared. Everything seemed to be falling into place. But when Lewis returned to the town on July 15, 1803, he found nothing but problems. Lewis had expected his keelboat to be finished by the time of his arrival and had planned to set off in only a few days. Instead, he found the uncompleted wooden frame and a drunken boat builder. Lewis was forced to visit the shipyard daily to pressure the builder into completing the project. To make matters worse, he had still not received word from Clark about whether he would join the expedition downriver.

There has been some debate about the location of the shipyard where the keelboat was built. For a long time, local tradition held that it was built up the Monongahela in the town of Elizabeth by the skilled boat builder John Walker. Walker was not a drunkard, however, and Elizabeth is fifteen miles from Pittsburgh by land. If Lewis was walking to the boatyard every day from Fort Fayette, as he mentioned in his journal, that distance seems too far. The Greenough Boatyard, on the other hand, was at the edge of Pittsburgh on the Monongahela near Sukes Run. It was the home to several large boat-building operations. When the boat was finally completed, Lewis and his entourage reported traveling three miles to Brunot's Island on the

first day. The Greenough Boatyard is three miles upriver from the island.

While waiting for his boat to be completed, Lewis gathered other supplies. Several Pittsburghers joined the expedition at that time, including Sergeant Patrick Gass, John Coulter, George Shannon and a black Newfoundland dog named Seaman. Lewis also acquired a cutting-edge firearm that would very quickly cause him trouble. He purchased a .51-caliber Girandoni repeating air rifle. When loaded properly, the rifle could fire twenty-two times without reloading.

Almost six weeks later, the boat was finally nearing completion. Two other smaller boats were purchased to accompany the mission, possibly from John Walker. And there was more good news—a letter had arrived from Clark. He had agreed to accompany the expedition. But there were also more problems. It was late August, and the Monongahela River was getting shallow. Time was running out. Finally, the keelboat was completed on the morning of August 31. Lewis wasted no time in loading the boats, and the expedition left the same morning.

As previously mentioned, the expedition's first stop was downriver on Brunot's Island, home of Revolutionary War veteran Dr. Felix Brunot and his family. While on the island, Lewis took the opportunity to provide a demonstration of his new repeating air rifle. After several shots, Brunot's cousin Blaze Cenas decided to try out the rifle. Somehow, he accidentally fired it and struck a woman

in the head about forty yards away. One can imagine the feeling that rushed over the men when they realized what had happened. They ran to the woman, expecting her to be dead, and discovered that the bullet had only grazed her head and pierced her hat. Once the relieved Lewis knew she was fine, he gathered his crew and set off again downriver as quickly as he could to avoid any more unpleasant delays. The expedition stopped to sleep near McKees Rocks. His men drank some whiskey and went to bed at 8:00 p.m. Thus ended the first day of what became America's most famous journey of exploration.

TESLA ASKS WESTINGHOUSE TO FINANCE HIS DEATH RAY

Nikola Tesla (1856–1943) was one of the most talented and advanced scientific thinkers of his day. One could dare say that his understanding of electricity, electromagnetism and electrical engineering bordered on the supernatural. Born an ethnic Serb in what is today Croatia, Tesla moved west across Europe and then to America. The eccentric scientist is credited with dozens of discoveries, inventions and advancements, including the induction motor, wireless communication before traditional radio, the Tesla coil, Tesla turbines, wireless transmission of electricity and many others. He is most famous for allying with George Westinghouse to produce an effective means of transmitting alternating

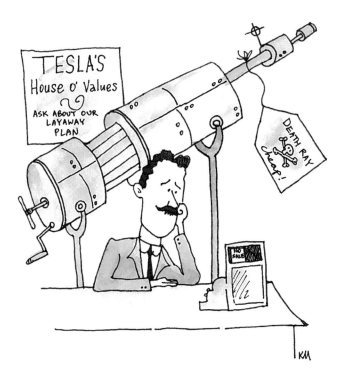

current, which was a more effective system than Thomas Edison's direct current. Much of today's electrical technology owes its success to the pioneering work done by Tesla. He had over one hundred patents in America alone. Tesla was also known to put on quite a demonstration with electrical arcs. This led some people to call him the "master of lightning."

Despite his success in science, Tesla still remained reclusive for much of his life. He never married and had few

close friends. He also had difficulties managing his money and never became wealthy like Edison and Westinghouse. In his later years, his experiments and theories took a turn to the unusual, and he was labeled something of a "mad scientist." One of the most controversial and bizarre inventions was his "death ray." Tesla told the press in 1934 that he had discovered a way to send "concentrated beams of particles through the free air, of such tremendous energy that they will bring down a fleet of 10,000 enemy airplanes at a distance of 250 miles." He believed that his weapon, which he called Teleforce, was so powerful that it would make war futile and obsolete. All he needed was someone to finance its construction.

One of the first companies he approached was Westinghouse Electric in Pittsburgh. He had worked with them successfully in the past and maintained amiable connections. Tesla wrote to Samuel Kintner of Westinghouse and tried to convince him of the invention's viability despite skepticism from the company's experts. The weapon seemed so advanced that it was like science fiction. Westinghouse Electric Company turned him down. Tesla tried to seek financing from other companies and even governments over the next decade. Though there was often interest initially, his weapon seemed too far-fetched for most to risk the large monetary investment. When he died in 1943, he was living in near poverty, and his greatest invention had never been financed. His notes and papers that dealt with the death ray were confiscated by the U.S.

government. Despite the fact that Tesla had become a U.S. citizen, his personal property was seized by the Office of Alien Properties. Over eighty trunks of papers were declared top secret by the War Department. Tesla's family eventually sued and got back much of the material. The papers concerning the death ray were not returned. Given Tesla's history of developing scientific advancements that were far beyond his contemporaries, one wonders what would have happened if Westinghouse would have said yes to his death ray.

CZECHOSLOVAKIA—MADE IN PITTSBURGH

Pittsburgh has been home to many immigrants throughout its history. The city is still peppered with ethnic enclaves and neighborhoods. Some of the immigrants came for economic opportunity. Others who were more politically active came to escape persecution and organize their fellow countryman from abroad. That is exactly what happened with some politically minded Czechs, Slovaks and Carpatho-Rusyns in the early years of the twentieth century.

On May 31, 1918, a group of Slovak and Czech political leaders signed the Pittsburgh Agreement in Moose Hall, just off Penn Avenue. World War I was nearing its end, and the document laid the framework for what would be a new Czech and Slovak republic in Europe. The new republic would be free from the influence of the larger European

powers. One of the signers of the agreement, Thomas Masaryk, became the first president of Czechoslovakia in 1920 when the new government took power. A copy of the agreement is housed in the collections of the Senator John Heinz Pittsburgh Regional History Center.

A Mob Attacks the Umpire

Pittsburgh sports fans are widely known for their fanaticism and loyalty to their teams. Though they may be loud, they are, for the most part, well behaved. There was one incident in the early days of Pittsburgh baseball, however, when those fans became an angry mob. On May 26, 1897, Pittsburgh was playing the Baltimore Orioles at home. Baltimore won the game by two runs, but Pittsburgh fans believed that Umpire Hurst made some bad calls. When the game ended, a crowd of five hundred angry fans gathered outside the clubhouse and waited for Hurst to emerge. When he came out, the crowd hurled insults and accused him of favoring the Orioles. Hurst became so angry that he struck one of the men who were blocking his path. This was a bad idea. The crowd then fell upon Hurst, who would have been severely beaten if some of the Pittsburgh players had not emerged and dragged him into the dugout to protect him. A group of ten policemen had to be sent to escort Hurst back to his hotel room.

BLOWING UP THE TROLLEY

On August 10, 1911, someone planted a bomb on the Pittsburgh, Butler, & Harmony Interurban Trolley line near Evergreen Hamlet. It was suspected that the explosives were planted by angry workers who had been on strike for two weeks. Whiskey flasks full of nitroglycerine were placed under the tracks and attached to percussion caps on the rails. That evening a trolley car containing twenty-five passengers ran over the caps and there was a tremendous explosion. The front of the trolley was blown into pieces, but its heavy construction actually shielded the passengers. They escaped with only minor injuries despite being thrown around in the car. Almost fifty feet of the tracks were destroyed, and the nearby station was heavily damaged. The blast shattered windows in homes and business for almost a mile.

While rescuers and police scrambled to help the passengers and control the situation, Detectives Roach and Sidenstrecker noticed a similar bomb on the tracks running in the opposite direction. Another trolley was due to come down that line any minute, so they ran up the track to flag it down. They managed to alert its operator and prevent a second explosion.

BARBERS ARRESTED FOR CUTTING HAIR

A police raid in the Hill District on May 14, 1906, resulted in the arrest of thirteen barbers and their journeymen. Their

crime: cutting hair on a Sunday. The barbers were in violation of Pennsylvania's blue laws, which, at the time, forbade work on a Sunday. Over a dozen customers, with their hair half cut and their faces half shaven, were turned out into the street by police. They wandered around the neighborhood, looking for people with razors and scissors who could finish cutting their hair. To be fair, the police arrested twenty-four women as well when they raided fourteen different tailor shops. Their crime: sewing on a Sunday.

OLD PLANK ROADS

In the mid- and late 1800s, travel in the Pittsburgh area could be hazardous. Roads in general were in terrible shape, especially in the outlying areas and surrounding communities. Most roads were still made of dirt and were hard on horses and the carriages that they pulled. In the early 1850s, some entrepreneurs came up with an alternative to the dirt road. They developed plank roads that would create a smoother surface for travelers and horses. Lumber was plentiful, so cutting wooden planks, about eight feet in length and a foot wide, and laying them one after another was not an excessive expense. The cost of the road was recovered and a profit made when tollbooths were set up at various locations along the roads. For a small fee, travel became much easier. Property values increased along the roads, and they benefited businesses and towns financially.

One of the longest and busiest of the plank roads was the Butler Plank Road. It ran from Allegheny City, through Millvale and Etna and then north on the same path as present-day Route 8. It was built in 1851 and had tollgates every five miles. The road was used by the stagecoach that ran from Pittsburgh to Butler. In an average year in the 1850s, the tolls would raise at least $10,000. The road continued to operate for over fifty years, though in 1864, a rail line was established between Butler and Pittsburgh that cut into profits. Allegheny County bought the plank road in 1905 at a cost of $65,000. The county paved the road the following year. One of the planks from the road survives today at the Depreciation Lands Museum in Allison Park along Route 8.

Another plank road that ran north was the Perrysville Plank Road. It started in Allegheny City and followed the route of present-day Perrysville Avenue and Perry Highway for seven miles. A humorous story is told about one man who refused to pay the toll one day because the road was in bad shape. By 1868, many of the planks on the road had disappeared, leaving large gaps with mud and dirt. A criminal defense attorney from Pittsburgh named Thomas Marshall used the road regularly. One evening, when he reached the tollbooth, he flatly refused to pay because of the condition of the road. The gatekeeper would not let him pass, so he promised to come back the next day with an axe to hack through the gate. To the gatekeeper's surprise, Marshall kept his word. For the next two years, the road's

owners sent bills to Marshall for the gate and toll that he did not pay. When they threatened to take the successful lawyer to court, he threatened a countersuit to revoke their charter. The owners agreed to void the bill in exchange for free legal advice from Marshall.

Other plank roads existed in Manchester, New Brighton, Temperanceville, Lawrenceville, Moon Township, Sharpsville and East Liberty. The weather in the region wore out the roads quickly, and most of the planks would have to be replaced in as little as five years. Eventually, most were replaced by rail or trolley lines and later paved surfaces in the early 1900s.

KILLED BY AN OIL WELL

On January 17, 1890, a worker was killed in a rather unusual accident at an oil derrick near Canonsburg, Washington County. The eighty-two-foot-high derrick was operated by the Fisher Oil Company and was located on the Hickman farm. Fisher Oil was test drilling in an attempt to locate more reserves of the valuable resource. That particular well had turned out to be dry, but it did contain a small amount of natural gas. It was decided to plug the shaft to prevent the gas from escaping. The two plugs were made of wood, five feet in length and over five inches in diameter. They were put into place successfully, and everything seemed to be fine for several hours.

Later in the day, two workers were on top of the derrick, changing ropes. Without warning, the plugs exploded out of the well and shot toward the top of the derrick like bullets. Too much pressure had built up behind them. John Moore was hit by one of the plugs and killed instantly. His body plummeted to the ground. The top of the derrick was knocked over, but the other man managed to survive. No one who had worked in the oil industry at that time had ever heard of such an accident.

THE PITTSBURGH POISONER

"I loved to see death in all its forms and phases and left no opportunity to gratify my tastes for such sights. Could I have had my own way, probably I should have done more." Those dark and defiant words were spoken by fifty-year-old Martha Grinder to a jury that was about to decide her fate in late 1865. Mrs. Grinder, known in the press as the "Pittsburgh Poisoner," had been the subject of sensational headlines for months after she was accused of poisoning at least two women and attempting to poison several others. Grinder confessed to the crimes and did not express any remorse.

One of the women who were murdered was Mary Caruthers. Caruthers had inherited money and purchased expensive clothes and a nice house and was moving up in local social circles. She was said to be a very attractive young woman. Ironically, she had inherited the money because

most of her family had been poisoned fifteen years before by a young woman in Carlisle, Pennsylvania. Some police speculated that jealousy had led Mrs. Grinder to poison Caruthers. At some point she prepared an arsenic-laced meal or medicine for the young woman. An earlier victim was Jane Buchanan. She had been staying for a few days at the Grinder household on Hand Street (Ninth Street) in February 1865 because she had to temporarily delay a trip to Philadelphia. Grinder served her an arsenic-laced meal. As she lingered near death throughout the night, Grinder failed to call a doctor or alert Buchanan's family or friends. She was dead in the morning. Grinder then stole the money that Buchanan had withdrawn for the trip and some of her clothes.

When the family came to claim the young woman's body and possessions, they realized that some of her belongings were missing, including her dresses. Grinder, wanting to prevent further inquiries, quickly offered one of her dresses for the burial. After the funeral, friends of Buchanan became suspicious of the entire episode and alerted the coroner. Unfortunately the coroner's jury ruled the death a result of natural causes. People around Mrs. Grinder continued to die and become ill. It was only after the death of Caruthers that the case was reexamined. This time the coroner determined that the cause of death was poisoning. Grinder was arrested and confessed to the two previously mentioned deaths. Investigators suspected that there were many more, but the two convictions were enough for a death sentence.

Martha Grinder was hanged in Pittsburgh on January 19, 1866. She went to the gallows smiling. A white hood was placed over her face, and the trapdoor sprang open at 1:15 p.m. The noose had become damp, and the rope did not slide properly. As a result, the Pittsburgh Poisoner struggled for several minutes, hanging in the noose, before finally becoming still.

HOGG'S POND

In the late 1700s, the "Golden Triangle" of Pittsburgh looked much different than it does today. If you could step out of a time machine onto the middle of Smithfield Street in 1795, you would be in for a surprise—probably because you would be standing in water. A large pond, known as Hogg's Pond, once covered a large portion of land between Grant Street and Wood Street. One end of the pond ran up against Grant's Hill, also known as the "Hump." Historians are not completely sure how the pond received its name. Early Pittsburgh resident and chronicler Neville Craig briefly mentioned a David Hogg in his writings. David was said to live on Fourth Street near the other end of the pond. Local historian S. Trevor Hadley believes that the pond was named after an early Pittsburgher known as "Old Granny Hogg." It has not been confirmed which, if either, of these two individuals gave his or her name to the pond.

Hogg's Pond did not last very long. With new construction and the gradual leveling of Grant's Hill, the pond became an ideal place to dump dirt. By the 1830s, the pond was mostly filled in, and the city continued to expand over top of it.

The First Armored Car Robbery

If you had to guess the location of the world's first armored car robbery, a reasonable guess would be Chicago or New York. Or perhaps one would guess some other place known for violent criminals and gangland activity. No one would suspect that the first armored car robbery actually took place in the quiet Pittsburgh suburb of Bethel Park. The crime took place around noon on March 11, 1927, on what is Brightwood Road today. The nine robbers, who went by the name of the Flatwood Gang, were led by a man named Paul Jaworski. The gang was originally from Detroit.

The armored car that they attacked was from the Brinks Company. It was accompanied by a "trail car" for extra security. Its cargo was the payroll for a nearby mine at Coverdale that belonged to the Pittsburgh Terminal Coal Company. To stop the vehicles, the gang placed a primitive landmine in the dirt road just before they arrived. Using a plunger, the gang detonated its bomb and launched both vehicles into the air. Though none of the armed guards was killed, all were left injured and disoriented. A crater was blown into the road, and the armored car was flipped upside

down. The gang escaped with the $104,000 and divided it among themselves. As the gang members sped away in their escape car, they got a flat tire. They split up and fled.

With the police hot on their trail, some members of the gang were captured within days. One of them was Jaworski, who turned on his friends and also revealed the location of some of the hidden money. While in custody he confessed to other robberies and murders back in Detroit and was eventually executed in 1929. Though most of the money was recovered, some was not and may still be hidden in the woods south of Bethel Park.

FIERY PHANTOMS

A strange local ghost story was recorded in an issue of *Keystone Folklore Quarterly* in 1961. In the summer of 1934, a young couple was walking along Legionville Hollow Road, just outside of Ambridge in Beaver County. It was early on a Saturday morning, and the couple was on their way into town to go shopping. They never expected to encounter anything unusual or unexplainable.

Suddenly, their eyes were drawn to some open land on the side of the road. They saw what seemed to be a ghostly bonfire. Around it danced vague and shadowy figures whose details were obscured. Other shapes resembled people sitting around the fire. Frightened by the scene, the couple ran farther down the road. When they looked back, the fire and the ghosts were gone, but a truck came

screeching to a halt just behind them. A surprised man jumped out and exclaimed, "Did you just see what I saw?" He went on to describe the exact same fire and figures that the couple had witnessed. They speculated that it might have been the ghosts of Indians reliving an old encampment. Or perhaps it was the phantom soldiers of General "Mad" Anthony Wayne who once passed through the area.

THE INDIAN SPRING

An interesting legend has been passed down for years about the Indian Spring at Evergreen Community Park in Ross Township. The legend tells of the supernatural origin of the spring. The park was once the property of the Sweadner family. One day in the summer of 1924, an old Indian visited the property and met the man who lived across from the Sweadner land, Jacob Imfang. The old Indian asked Imfang if there was a spring nearby where he could get a drink. Imfang took him to the spring that gushed out of an unusual rock formation. The Indian took a drink and then fell to his knees, thanking the Great Spirit for leading him to his destination.

The Indian then told Imfang a story about the spring, and it became clear that he had come searching for it. He said that his great-grandparents had fled their tribe because they were deeply in love. They were trying to avoid the marriages to other members of the tribe that

had been arranged for them. The young couple was chased relentlessly, and when they finally escaped their pursuers, they were very hungry and thirsty. Desperate for water, they prayed to the Great Spirit to provide sustenance for them. Before their eyes, water flowed forth from the rocks in front of them. The Indian Spring has been there ever since. The old Indian had made a pilgrimage to see the place where the miraculous event had occurred.

As the word spread, many visitors came to see the spring and drink the water. Some brought bottles so they could take some of the water with them. Other residents of the township say that the story is a fabrication and that there was nothing special about the spring. The stones were merely arranged around it intentionally. This skepticism has not stopped the story from resurfacing every few years as an interesting anecdote in the region's history.

DON'T GET DECAPITATED

A humorous twist was put on what would otherwise have been a mundane article that ran in the *Pittsburgh Daily Gazette and Advertiser* in November 1866. The article was simply titled "Decapitation." It began by stating the obvious with the line: "No part of the human structure is so essential to existence as the head, and as a natural consequence it is highly prized by any person who desires

to remain a little longer on God's footstool." Contrary to the expectations built up by the title and first line, there was no actual decapitation involved in the story, only the threat of it. A former employee of the Western Pennsylvania Railroad Company, Dennis O'Neil, was walking near his old place of employment in Sharpsburg when he ran into his old boss. Mr. Wheeler was the superintendent of that particular stretch of railroad and did not like O'Neil at all. He threatened to decapitate him if he ever came near the rail line again. O'Neil must have taken the threat seriously enough because he reported it to the authorities. Wheeler was arrested and held for trial. It is not clear if any of the charges were upheld.

A HERO IN ALLEGHENY CITY

May 12, 1890, started out as a normal day for E.A. Maxwell of Allegheny City (now Pittsburgh's North Side) He was riding into town on the electric streetcar. It was not overly crowded, carrying only one other man, four women and three children. As the streetcar descended the final steep grade into town, Maxwell realized that something was wrong. The car was not slowing at all. He looked up to see the panicked motorman trying to pull back the break. Two of the women fainted, and the other passengers screamed, realizing that a crash was imminent.

Maxwell did not panic and kept his focus. He ran to the front of the car and yanked the motorman back by his shirt

collar. Maxwell was much larger and stronger, weighing around 225 pounds. With the motorman clear, he took hold of the brake and pulled as hard as he could. Sparks flew from the wheels as people watched the car charge past. Just then, Maxwell looked up to see another streetcar coming directly toward them on the same track. At the speed they were going, the other car would not have time to turn off onto the side track. Maxwell knew that if he did not slow down the car, they would all die. He planted his feet again and gave one more pull on the brake. The car slowed just enough to miss the oncoming streetcar by a few feet.

Just after clearing the other streetcar, the runaway car struck the curb. While it helped to stop the car, the jolt launched Maxwell out into the street. He slammed onto the cobblestone and was knocked unconscious. The impact broke his ankle and dislocated his hip. Police arrived on the scene quickly and called for doctors. The passengers on the streetcar had only minor bumps and bruises, but Maxwell was in much worse shape. Maxwell regained consciousness in time to hear the cheers of the crowd as he was put on a stretcher. He waved back to them with his uninjured hand.

THE DARK PLACE

American Indians viewed the wilderness as a spiritual and magical place. But contrary to popular stereotypes, they often feared it as much as the European settlers. The

wilderness provided the necessities of life, but it also brought very real physical dangers. In addition to the difficulties that could be meted out by Mother Nature, the wilderness was also home to the witches, evil spirits and giants of their mythology. Some areas were considered more ominous and dangerous than others.

The Indians who inhabited western Pennsylvania supposedly feared one particular place in the wilderness. According to legend, the local tribes referred to the area across the river from Pittsburgh's point as the "Dark Place." This area later became part of Allegheny City, and after it was annexed by Pittsburgh in 1907, it became the Allegheny West section of the North Side. The tribes allegedly used the area as a burial ground for their dead and the enemies they killed. At that time, the geography of the land was very different, and much of the area was marsh. The strip of land along the river where PNC Park and Heinz Field are located, now referred to as the "North Shore," was once a series of islands separated by a narrow channel. The largest of the islands, known as Smokey Island and later Killbuck Island, was the site used by some of the Indians to torture their captives. Members of General Braddock's ill-fated expedition were executed there after they were captured during the Battle of the Monongahela in 1755. Their painful screams were heard by the French across the river in Fort Duquesne. The legend says that the local tribes avoided crossing through the area because the land was tainted with the spirits of their dead enemies. Unfortunately, the origin

of this legend cannot be traced. It is unclear whether it represents an authentic native tradition or merely reflects the fears of the early European settlers.

During the industrial era, the area became home to some of Pittsburgh's most prominent citizens and capitalists. They included the Darlington, Horne, Kaufmann, Jones, Laughlin, Byers, Thaw and Scaife families. Today, the area is full of allegedly haunted houses and locations. Given the number of stories that have been told, it would seem that the Dark Place has one of the highest concentrations of hauntings in America. This has led to speculation that the

Indian legends may have been true after all. The following are just a few of the alleged hauntings that have occurred in the Dark Place.

The Thaw Mansion on North Lincoln Avenue is supposedly haunted by Mrs. Mary Thaw. In the late 1800s, the Thaw family made their money investing in railroads and transportation. For years Mrs. Thaw was a prominent and respected woman in high-class social circles. In the early 1900s, however, her reputation was tarnished by the actions of her son, Harry. Harry Thaw was a playboy who spent his money freely. He eventually fell in love with an attractive showgirl from Tarentum named Evelyn Nesbitt. Nesbitt had become famous for posing for pictures as the "Gibson Girl." Thaw soon became obsessed with Evelyn's past. He wanted to know every detail about her relationship with her first lover, the famous architect Stanford White. White was known for his womanizing and his habit of seducing young showgirls. One night in 1906, Harry and Evelyn were attending a function at Madison Square Garden in New York City. Harry spotted White at another table and, in a fit of rage, walked over and shot him in front of hundreds of witnesses. When the case went to trial, Thaw's attorneys exposed White's exploits to the public to gain sympathy. Thaw was portrayed as defending his wife's honor. He was found not guilty by reason of insanity and was committed to an institution. He and Evelyn divorced a few years later.

The trial was a media circus. Mrs. Thaw lost much of her social standing and was forced to deal with the public reaction

to the trial. She even wrote a pamphlet defending her son, but it was too late to save his reputation. Harry embarrassed her again in 1917 when he attempted suicide by cutting his own throat after being charged with whipping a teenage boy. It is said that she was never able to completely accept or deal with the incidents. Perhaps that is why her restless ghost has been seen staring out the windows of the first floor and strange lights have been seen flashing in the attic.

In the late 1780s, early settlers set aside a shared grazing area known as the commons. Twenty-five years later, during the War of 1812, the open area was used by four large field hospitals. Thousands of soldiers were treated at these hospitals, and many did not survive. Soon after the conflict ended, reports began to surface of ghostly soldiers wandering the area. During the Civil War, many sightings occurred on Hogback Hill. After the war, a monument to the fallen soldiers was built there, and it was renamed Monument Hill. The ghosts of the dead soldiers finally seemed to be at peace. In the 1930s, part of the monument was moved and the sightings began again. Today the hill and that portion of the commons have been absorbed by the campus of the Community College of Allegheny County.

Another ghost tied to the War of 1812 was said to haunt Rope Way, named after the rope works adjacent to the alley in the early 1800s. The rope works provided the rigging for Commodore Perry's fleet. Sometime after his famous victory on Lake Erie, ghostly moans started to be heard in

the alley. The rope works burned in 1842, but the ghostly moans lingered on.

The Liehman house on Beech Avenue was built by Moses Liehman in 1888. After his wife died in 1890, Moses became something of a ladies' man and kept a journal of his exploits. When he sold the house in 1910, the journal remained hidden until it was discovered by workers carrying out renovations a few decades ago. Since that time, the specter of Liehman has been seen by women who enter the house. There has also been a substantial amount of poltergeist activity, including the violent shaking of the entire home.

The former Darlington house on North Lincoln Avenue is allegedly haunted by the ghost of Harry Darlington Jr., who may have been the victim of foul play. Harry's wife had secretly been having an affair with Harry's uncle, Henry. When news of the scandal became public in 1902, his reputation suffered tremendously. Unable to bear the shame, he supposedly went to his room, locked the door and shot himself. The first person his wife called was Henry, and he kicked in the door to discover the body. Years later, during renovations, a secret door was discovered that led into Harry's room. Some speculated that his wife had killed him and made it look like a suicide. Interestingly enough, the bloodstain on the floor always comes back, no matter how many times it has been cleaned and sanded away. Perhaps it is a message from Harry.

Numerous other hauntings and strange occurrences have been reported in other private homes and businesses

in the Allegheny West and North Shore areas. Is it just a coincidence? Probably, but some people believe that the area really is a cursed and dark place.

ELIXIR OF INVULNERABILITY

Another odd legend has been associated with the previously mentioned Smokey Island (sometimes spelled Smoky on old maps) that was once across the river from Pittsburgh's Point. After the defeat of General Braddock's army by the French and Indians at the Battle of the Monongahela in July 1755, the Indians took surviving British captives to the island. The handful of survivors suffered a fate worse than death on the battlefield. They were beaten, tortured and burned alive on stakes. French soldiers reported hearing their screams across the river at Fort Duquesne.

According to legend, at least one of the British troops, often said to be Scottish Highlanders, was able to prevent himself from being tortured and ensured a quick death. Supposedly, he convinced several of his captors that he knew how to create an elixir that could make parts of the body invulnerable to harm. The Indians let him gather the herbs and plants that he claimed were necessary, but they insisted that it be tested on him. The man made his elixir and rubbed it on his neck. Then he told the Indians that they would not be able to cut off his head with even the hardest blow. The Indians easily separated

his head from his body, but he had prevented a slow and painful death.

This story is almost certainly a fabrication but has been occasionally told as if it were true. Since no one survived the torture on Smokey Island, the story would have had to come from one of the Indians. Though it is possible, it is highly unlikely. It seems that the story was probably made up to demonstrate the superiority of the European intellect over the "savage" Indian. The most dramatic version of the tale appears in the WPA's *Story of Old Allegheny City* from the 1930s.

AN EARLY CAR ACCIDENT

One of Pittsburgh's first "car" accidents occurred on September 28, 1897. The car, which was described as a horseless carriage, was powered by a steam engine. Its passengers were Detective P.J. Fitzgerald and his wife, Mrs. William McCarthy, Miss Newell and four children. They were all enjoying the ride on the cutting-edge transportation when the horseless carriage went out of control. It plunged over a thirty-foot embankment off the side of Beechwood Boulevard. Everyone except Mrs. McCarthy was thrown from the vehicle as it tumbled down the hill. This probably saved their lives. Mrs. McCarthy was not as lucky. When the vehicle hit the bottom, one of the steam cylinders in the engine exploded. McCarthy

was struck in the head with a piece of metal. She was not expected to survive the injury, but no follow-up reports appeared in the papers confirming this.

JUDGE MUSMANNO VERSUS THE COMMUNIST SECRETARY

Judge Michael A. Musmanno had a long and interesting career that was not without controversy. Musmanno was born in Stowe Township in 1897 and became a lawyer, a state congressman, a judge in Allegheny County's Common Pleas Court and eventually a justice on the Pennsylvania Supreme Court. He also served as an appellate attorney for Sacco and Vanzetti, fought to eliminate the coal and iron police in Pennsylvania, waged an early campaign against drunk driving and was involved in numerous other causes. He wrote several books, some of which eventually were turned into movies (*Black Fury* and *Ten Days to Die*). During World War II, Musmanno served with General Clark and worked his way up to the rank of rear admiral in the navy. During the occupation of Italy, he served as military governor of the Sorrentine Penninsula. When the allies occupied Germany, he interviewed the survivors from Hitler's bunker to determine the fate of the Nazi leader. Musmanno also became a judge in the Nuremberg Trials where he tried numerous war criminals. After the war, he became ardently anticommunist. After being sold a communist propaganda pamphlet on the street in

Pittsburgh in the late 1940s, he launched a crusade against domestic communists. Musmanno led a raid on the local Communist Party headquarters, which was directly across the street from the courthouse. In 1950, he brought a sedition case against Steve Nelson and the other leaders of the local communist party and was involved in several other legal actions.

Musmanno was also well known for his dramatic flair and his willingness to make his opinions known. This is evidenced by an incident that occurred during the height of his anticommunist activities. In March 1950, Musmanno refused to allow a woman who was a suspected communist to be seated on an Allegheny County grand jury. Thirty-five-year-old Alice Roth, a stenographer and secretary, had been identified by FBI informant Matt Cvetic as a communist organizer in East Pittsburgh. Instead of quietly dismissing her, Musmanno made it clear to everyone in court why he thought she should not be on the jury. The judge launched into a lengthy explanation, containing the statement, "The grand juror must be loyal to the Constitution of the United States and respect its laws; the grand juror must also be above suspicion; judicious in temper, considerate in judgment and without bias." His statement described the dangers of communism and its threat to the American way of life. He ended by pointing out that Mrs. Roth was an active communist who refused to confirm or deny the accusations against her. Roth stood up and silently walked out of the courtroom.

The story of the dismissal was all over the newspapers the next day. It was an unprecedented move for a judge. Roth made no statement to the press; however, Steve Nelson did. He promised to protest the action and accused the judge of political grandstanding. On March 20, Roth's attorney filed a petition with the state supreme court, demanding that they force Musmanno to reinstate the juror. The supreme court wanted to know exactly how and why Roth was dismissed. Though they ruled that he was incorrect in his dismissal of the juror, they did not force him to reinstate her. In a speech delivered later that year, Musmanno declared that despite his respect for the Pennsylvania Supreme Court, he would make the same decision again in similar circumstances. Musmanno continued crusading against communism for the rest of his life. He died on Columbus Day 1968.

AN ELECTRICAL SHOW ON SMITHFIELD STREET

Strong winds wreaked havoc on Pittsburgh's telephone, telegraph and trolley lines on January 23, 1890. Damage to one particular line on Smithfield Street resulted in a dangerous display that could be seen for blocks. That morning, a telephone line fell across the wires of the Pleasant Valley Street Railway Company. Though the phone line was dead, the streetcar lines were carrying an electrical current. They broke loose and danced around like "fiery serpents," as one newspaper described them.

The live wires melted the snow everywhere they hit the ground and burned wood and other surfaces they had contact with. Sparks were flying everywhere. A crowd gathered to watch the lines at a safe distance, and all traffic on Smithfield Street was stopped. After twenty minutes, the lines finally burned through and melted, falling harmlessly to the ground. More damage was discovered after the lines had stopped. They had apparently come into contact with the active telephone line and the police patrol wires. The surge caused by the contact damaged much of the police network, damaged their connection boxes and cut off communication. Luckily there were no injuries to anyone on the ground.

A Witch in Harmar Township

B.F. Brewster, a lawyer and judge, had moved to Harmar Township in 1798. He had purchased and settled on Twelve Mile Island in the Allegheny River. At the time, he probably never thought that he would be asked to preside over the informal trial of a witch. Details of the incident are sketchy because it did not occur in a courtroom. The little information that is available seems to have come from Brewster himself.

The trouble began in 1802 when an angry crowd of people dragged a woman to Brewster's home. They demanded that she be tried as a witch. Brewster thought

this was ridiculous, but the crowd insisted. He assumed that no one would come forward with real evidence (because it did not exist) so he decided to hold an impromptu trial to appease the crowd and find the woman innocent. Unfortunately, his plan backfired. Numerous witnesses

came forward with what they thought was evidence proving their accusations. Many started demanding that the witch be executed. Brewster had to take a new approach. He managed to convince the crowd that he needed to research the law in regard to witches before he could deliver a decision. It would take some time. The crowd reluctantly agreed, apparently believing that Brewster was taking the case seriously. While the crowd waited, Brewster had the accused woman sent away for her own safety. When he returned to speak to the crowd, he informed them that the woman was gone, so no verdict could be rendered. The crowd was furious, and some even threatened to harm or kill Brewster, but the woman was safe.

PITTSBURGH EARTHQUAKES

The city of Pittsburgh rarely experiences earthquakes. Often when they are felt, it is actually the shockwave from a much larger quake in the distance. Still, the Pittsburgh area has had an occasional rumbling. In late 1811 and early 1812, the New Madrid, Missouri quake and its aftershocks could be felt in Pittsburgh. Most estimates put the quake's strength at 7.0 to 7.5 on the Richter scale, but the tremors felt in western Pennsylvania were nowhere near that intensity. Another large quake that was felt in the city occurred decades later and was centered near Charleston, Missouri. The 1895

"Halloween Quake" was a 6.8 in magnitude and could be felt throughout much of Pennsylvania, even though it caused no damage here. The shaking was noticed in Bellevue, McKeesport and other outlying areas.

Some of the minor quakes have occurred closer to Pittsburgh but were much weaker in strength. On September 22, 1886, tremors were reported in Beaver County around 8:45 p.m. The shaking only lasted about half of a minute, and no damage was reported. Most people who felt it thought that a natural gas tank or something else had exploded (a much more common occurrence). An earthquake that occurred to the south near Washington, D.C., was felt as a slight tremor in this region on May 31, 1897. It lasted for about a minute. In 1935, a larger earthquake, centered in Ottawa, was felt in Pittsburgh and throughout the northeastern part of the United States. It missed being a second Halloween Quake by a little more than an hour. On November 1, a few minutes after 1:00 a.m., Pittsburghers were awoken from their sleep by tremors. The shaking was strong enough to flood emergency lines with calls from worried citizens. The quake was felt for a little over a minute but caused no damage. A 5.2-magnitude earthquake occurred north of Pittsburgh, twenty miles to the west of Sharon, in 1998. It happened during the afternoon of September 25. Most of the damage was minor and contained to Mercer County, but the shaking was felt in Pittsburgh and throughout much of western

Pennsylvania. Coincidentally, while writing this book, another quake was felt in Pittsburgh. On June 23, 2010, the shockwave from a quake in Toronto reached the city and caused some minor shaking.

EXPLOSION AT THE BOILER WORKS

At 12:05 p.m. on March 22, 1899, a massive explosion tore through the West Point Boiler Works on Twenty-third Street in Pittsburgh. Windows shattered in the surrounding structures and the forceful tremor was felt blocks away. The building was reduced to rubble. Luckily the building was made of brick, so the fire did not spread far. Rescuers reached the smoldering ruins quickly and discovered six men dead and twelve wounded. The number of casualties could have been much higher. Just moments before the blast, more than forty employees had left the building to have lunch. The six men who were killed—Gus Linnebau, James Carter, Jacob Rheinheimer, Charles Aulenbache, Daniel Clark and Stephen Carter—were all between the ages of twenty-five and forty-five. Newspapers reported that the boilers had been inspected six months before and no problems had been found. The cause of the blast was never determined.

A BAD STORM ON THE FOURTH OF JULY

A very strong storm blew through the Pittsburgh region on the Fourth of July in 1878. It had been a beautiful summer day until 3:00 p.m. Suddenly a torrential downpour burst from the sky with accompanying winds of more than thirty miles an hour, with gusts that were even stronger. Severe lightning also accompanied the storm. In two hours, almost three inches of rain fell on western Pennsylvania. Hail the size of chestnuts pelted the ground, buildings and people in some areas. Hundreds of trees were toppled by the strong winds. The tracks of the Allegheny Valley Railroad and the Pennsylvania Railroad were washed out in several locations because of flash flooding, and several railroad employees drowned. Several homes in Soho and along Forbes Avenue were washed away. The Vesta Oil Works at Negley Run was struck by lightning and the entire facility burned. The strike had ignited the eighty thousand barrels of oil that were present on the site. A stable in East Liberty was also struck by lightning, and three horses were killed in the fire.

The biggest tragedy occurred on the Ross farm near Sharpsburg. The German Lutheran Church was having a Fourth of July picnic when the rain started. The picnickers ran for cover, and many of them sought shelter in a large wagon. Unfortunately, the wagon could provide no protection for what happened next. A large tree was blown

over onto the wagon, crushing it. Ten people were killed instantly and fifteen more were wounded. After 5:00 p.m., the storm stopped as quickly as it started, leaving damage and destruction in its wake.

THE TURNPIKE PHANTOM

On July 26, 1953, thirty-year-old truck driver Lester Woodward pulled his tractor-trailer off the Pennsylvania Turnpike at the Irwin exit. It was Saturday night, and he was tired from driving all day. Woodward parked in an empty parking lot just off the road and went to sleep. He never woke up. Sometime during the middle of the night, a man approached the cab and fired a .32-caliber slug into Woodward's head.

The next morning his body was discovered by another trucker. Police were called, and when they discovered that his wallet was empty it was assumed to be a robbery. A fatal multivehicle accident had occurred overnight nearby on the turnpike. It was caused by a speeding car that the police believed may have been the killer escaping. The murder was assumed to be an isolated incident, but that view quickly changed.

Three days later, another dead truck driver was discovered at the Donegal exit in a gravel parking lot. The victim's name was Harry Pitts, and he was thirty-nine years old. He had been shot through the mouth with a .32-caliber bullet.

The crime was similar to the first. Tire tracks were found from the killer's car that stretched across both directions of traffic, ultimately going west. The next day another trucker was shot just over the border in Lisbon, Ohio, on Route 30. John Shepard was thirty-six and had pulled off the road to sleep just like the previous two victims. He was luckier than the others, however, because he survived the attack. The .32-caliber bullet struck him in the jaw. When his attacker realized that he was not dead, he demanded money. He ordered Shepard to take off his pants and watch, which he quickly picked up and threw into his car before driving away.

By the time of the third shooting, truckers were becoming worried. Some started sleeping and traveling in groups. State troopers began to scrutinize vehicles on and around the turnpike, pulling over anyone who seemed suspicious. The media dubbed the killer "the Turnpike Phantom." For months there were no solid leads, even when an $11,000 reward was offered by the Pennsylvania Truck Motor Association. Then, in early October, Shepard's watch was discovered in a pawnshop in Cleveland, Ohio. The man who had pawned it was twenty-five-year-old John Wesley Wable. Police discovered that he was still living nearby, but when they got to his apartment, they only found his twenty-two-year-old girlfriend. Wable had left without paying the rent but had left the pistol used in the crimes. He was unemployed and had actually been in jail from August 6 to September 23 for not returning a car he had rented. Wable's father eventually settled things with the car dealer

so he was released and the case dismissed. Ironically, he had actually confessed to being the Turnpike Phantom while he was being held, but the police did not believe him. Now he was out and on the run.

Eventually authorities caught up to him in Albuquerque, New Mexico. He led them on a chase by car and escaped on foot. Later, an observant nurse spotted him walking near railroad tracks, and the police finally captured him. Once in custody, Wable changed his story and claimed that a man named Jim Parks had actually done the shooting and that he was only an accomplice. The police could never find a trace of the mysterious Parks. The jury did not believe Wable's new story either. He was convicted of the two murders and executed in Pennsylvania's electric chair on September 26, 1955.

MOUNT ODIN PARK: THE OFFICIAL GOLF COURSE OF THE NORSE GODS

Well not really, but the man who donated the property just off Route 30 in Westmoreland County might have liked to think so. Dr. Frank Cowan, who lived from 1844 to 1905, was described as an "eccentric genius." He was a lawyer, horticulturist, medical doctor, poet, author, editor and printer. He also served as a secretary to President Andrew Johnson and was once a district attorney. Cowan was also obsessed with Norse mythology.

Everything on his property was given Norse names. His interest in horticulture was evident in the fact that he planted two thousand different species of plants and trees on the land. When he died, Cowan left his property to the people of Greensburg and Westmoreland County as a public park. Mount Odin Park was named after the most important of the Norse gods. The public golf course was added later.

One-Eyed Farm

An electrician from Pittsburgh named D.J. Cable briefly stayed at a farm in Butler County in the summer of 1891. As he performed his work, he noticed a common theme on the farm—living things seemed to only have one eye. Cable had not discovered a Cyclops farm. All the animals had started with two eyes and had lost one. He noticed the peculiar characteristic while talking to the lady of the house, who had lost one eye ten years earlier because of disease. Her pet bird, in a cage, also had only one eye. The housecat and two dogs had all lost one eye. A sheep that was kept as a pet also had only one eye. Cable never inquired about what had happened to the animals, but he did tell the story to the *Pittsburgh Dispatch*. The farmers' names were not divulged.

A WATER TANK COLLAPSE

August 7, 1912, started out like a normal summer day at the Union American Cigar Company. The young women who rolled the cigars in the six-story building at the corner of Twenty-eighth and Smallman Streets reported to work as usual. On the roof, a new water tank had just been installed, and it was in the process of being filled. By late afternoon, about three thousand gallons were in the tank, but it was not yet full. Then something tragic happened. The faulty supports for the tanks gave way, and the heavy tank plunged down through the roof. It fell completely through the sixth floor and slammed on to the fifth.

No one was occupying the sixth floor, but around 150 young women were working on the fifth. Debris and water flew everywhere around the floor and down the stairwell. Upon hearing the crash, the 500 employees who worked on the lower floors attempted to flee, and many were crushed and injured in the crowd. Eventually they all got outside, and fireman and police arrived on the scene. It was too late for some of the women, however. Three who were right under the water tank were killed, and over a dozen were seriously wounded in the accident.

A Burning Balloon and an Angry Crowd

A crowd of over five thousand people gathered in Highland Park on the afternoon of July 25, 1891, to watch a hot air balloon take off. The launch was supposed to happen between 2:00 and 5:00 p.m., but at 5:00 p.m., the balloon was only partially filled. The crowd was becoming impatient; a group of boys pushed in close to the men who were holding the ropes securing the balloon. In the commotion, one of the ropes slipped loose, and the side of the partially inflated balloon leaned into the fire. It burned a hole in the side, but the fire was quickly put out. Still, the balloon was now unable to be flown.

One of the men who had been holding the ropes began to yell at the boys who had pushed in on their work. The boys yelled back and taunted the man. Soon almost one hundred boys had surrounded the man, and many began to pelt him with green apples that they had taken from a nearby orchard. There were so many boys that the man was forced to flee. The children chased him until the resident of a home up the street allowed him to seek shelter inside. The police were called, and the balloon flight was delayed until the following week.

Nike Missile Bases

Just as it had been in the Civil War, Pittsburgh's heavy industry and technological advances made it a potential

target again during the Cold War. The city was a fixture on the Soviet "first strike" list for decades. In the event that direct conventional or nuclear warfare would erupt between the superpowers, western Pennsylvania's manufacturing potential and atomic energy advances posed a threat. Tensions were especially high in the early years of the conflict. In 1952, the Army National Guard completed a study that identified Greater Pittsburgh's strategic weaknesses. Though the industries were dispersed all along the river valleys, making mass bombing more difficult, they were still susceptible to pinpoint and precision bombing. In fact, the various industries' proximity to rivers made that type of bombing easier. As a result, the decision was made to construct a series of missile bases around the region to provide protection.

The bases would house the newly developed Nike missiles. They were the first guided surface-to-air missiles used by the military and were the perfect weapon for shooting down enemy bombers. Twelve bases were constructed around the region in the hilly terrain of Allegheny, Washington and Westmoreland Counties. The sites were in Finleyville, Bridgeville, North Park, West View, Irwin, Plum, Rural Ridge, Dorseyville, Elizabeth, Herminie, Elrama and Robinson. A command center was also constructed in Oakdale. Each facility was manned by approximately one hundred soldiers.

The missiles themselves were almost 20 feet long and around twelve hundred pounds. Two different models

were used during the period that the bases were in operation. The earlier model, the Ajax, had a twenty-five-mile range, could reach 70,000 feet and traveled at 1,600 miles per hour. The later model was the Hercules. It traveled twice as fast, had a range of 90 miles and a ceiling of 100,000 feet. Antiaircraft guns were dispersed in other communities throughout the region to provide another layer of protection.

The missiles were unveiled to the public in 1955 with a parade and much fanfare. They provided a sense of security for those working in this industrial region. However, in only four years, half of the bases were closed. A brief "thaw" in the Cold War and the longer ranges of the new missiles made some of the bases unnecessary. By the 1970s, technology had changed substantially with intercontinental ballistic missiles and advanced nuclear weaponry, so the Nike missiles were becoming obsolete. The threat of direct nuclear conflict also appeared more and more unlikely. In 1974, the government closed the last of the bases. In the years since, some have been sold and repurposed, while others remain vacant, silent reminders of a tense time in American history.

A Diamond Thief Escapes

The *New York Times* carried a very brief article describing the escape of Rialto Tefft, a diamond thief, from the Allegheny

Central Police Station on March 23, 1894. Tefft had been involved with a major diamond heist in Washington, D.C., and fled in the direction of the Pittsburgh region. He was caught by authorities in Allegheny City (now Pittsburgh's North Side) and was being held in a cell at the police station. It was there that he planned his escape. Like in the plot of a bad movie, Tefft was able to saw through the bars of his window at night. It is not clear how he obtained the necessary saw or file. In the morning, when most of the guards were attending hearings, Tefft pushed out the bars and escaped just shortly before an officer from Washington arrived to take him into custody. It is not clear if he was ever recaptured.

AN AXE MURDER

Ernest Ortwein, who sometimes went by the name Ernest Love, came to Pittsburgh in 1872. He was a German and had served in the Franco–Prussian War (1870–71) in Europe. He came to America to get a new start. At least, that is what he had planned. Ortwein did not have much luck at first. He moved from job to job and made very little money. In 1874, he met John Hamnett of Homestead, who offered him a job as a farmhand. Ortwein accepted the offer.

After three months, Ortwein still had little money. Though he lived on Hamnett's farm and was treated as a member of the family, he wanted his own wealth. On

April 29, he decided to do something drastic. His actions would shock residents of Homestead, Pittsburgh and all of southwestern Pennsylvania. The details of the events of that night came from his own mouth when he eventually confessed to police. When the family was asleep, Ortwein retrieved an axe. One by one he snuck into the bedrooms of John and his wife, Agnes; their daughters, Ida and Emma; and a boy named Robert Smith who worked on the farm. He hacked each one to death. When they were all dead, he dragged the bodies into a pile and lit them on fire in an attempt to cover up the crime. He grabbed all the money he could find in the house—$16.17—and a watch and some jewelry before he fled.

The fire alerted the neighbors, who searched for the family once it was extinguished. To their horror they discovered the mutilated and burned remains. It was clear that they had not died because of the fire. Police immediately began looking for Ortwein because his body was not with the others. The following day, Ortwein visited a friend on Hope Street in Allegheny City and then proceeded to a nearby bar. While drinking, he mentioned the murder to someone who was sitting in the bar. The unidentified person alerted police, and Ortwein was arrested shortly thereafter.

In police custody, Ortwein admitted his guilt. At first he claimed that his motive was robbery. Then he changed his story. He stated that since the war, he was having "spells" where he did things "without motive" and that robbery was not the primary reason for his crime. Others were not

so sure. While in police custody, several false confessions circulated in the press ascribing the crime to other motives. The most prominent said that he had tried to force himself on one of the daughters and was caught in the act. He murdered the family in retaliation. All of these other confessions proved to be false. Ortwein was given the death penalty, and he admitted that he deserved it. Citizens in Homestead had watched the trial closely and were prepared to seize and hang Ortwein if he was not executed. They were pleased with the decision. Around noon on February 23, 1875, Ortwein was hanged. His body was given to medical professionals as per his wishes so that they could examine his brain.

HALF-MARRIED

Joseph Fischler and Helena Schmeill went to see Alderman Hartman of the Twenty-seventh Ward on August 6, 1891. They wanted to get married and brought the appropriate license. The ceremony began in the usual fashion, and everything seemed fine until about halfway through. At that point, Hartman realized that the couple was Catholic and refused to proceed any further. Hartman had apparently made it his own rule never to marry Catholics. Luckily for the couple, Father Schner, a Catholic priest, came to their rescue and finished the ceremony in Allentown.

The Bad Luck Bridge

The Wabash Bridge seemed to be surrounded by bad luck from the very beginning. Some writers have even described it as cursed. Most people today do not remember the bridge that once stretched more than eight hundred feet over the Monongahela River because it was torn down in 1948. In 1902, railroad tycoon George Gould ordered its construction as part of his own transcontinental railroad system. He had recently constructed a new railroad terminal on Water Street, and the new bridge would link it to the Wabash Tunnel across the river.

Bad weather and flooding hampered early work on the bridge site. An outbreak of smallpox also debilitated the workers and slowed progress. It seemed as if every time one problem was solved, a new one appeared. Finally, on October 20, 1903, the two sides of the bridge were to be connected over the river. Several barges and boats were in place below, and cranes were maneuvered into position on the bridge to place the central beams. Workers were everywhere, guiding the steel beams up from the barges and into position. Suddenly, the carrier that was supporting one of the cranes gave way, and steel beams, machinery and workers were thrown through the air. Some men were crushed by beams and equipment. Others were launched off the bridge and into the river, 109 feet below. Men on the barges below attempted to dodge the falling steel. Some jumped into the river. Seven men were killed on the bridge

and three on the barges. Two workers who plunged into the river from the bridge survived the fall. Thomas Shelley reportedly said, "My fall to the river was quick, but I thought a whole lot in that short time." Another worker managed to grab a safety line as he was falling from the bridge. He was able to climb down to a barge below.

Despite the setbacks, the bridge was finally completed in 1904 and opened to freight traffic and passenger trains. It turned out to be a financial disaster. The new line could not compete with the Pennsylvania Railroad. After only four years the bridge and terminal were placed into receivership. Eventually it passed into the hands of the Pittsburgh and West Virginia Railroad. The new owner eliminated passenger traffic when he found it was not profitable. The terminal caught fire and burned in 1946, and the Wabash Bridge no longer had a purpose. Two years later, the rusting and unattractive bridge was taken down.

PRESIDENT HARRISON'S UNPLEASANT VISIT

Near the end of May 1890, President Benjamin Harrison made a visit to Pittsburgh. It turned out to be an unpleasant one for almost everyone involved. Various dignitaries and the reception committee soon realized that Harrison did not want to be in the city. Trouble began as soon as the president arrived at the train station early in the morning. Only two hundred people had bothered to assemble to greet the commander in

chief. Hudson Samson, the city's most successful undertaker, was the master of ceremonies and the head of the reception committee. Despite his best efforts to rouse the crowd to cheers, the president was only greeted with mild applause. Apparently, he expected more public adulation.

Two military companies were waiting at the station as an escort and had cleared a path to Harrison's carriage. Unfortunately, the reception committee accidentally took him out of the wrong side of the car and into the small crowd. They pushed their way through the people and got the president to his carriage. Harrison was in such a hurry, and the committee was so flustered, that the carriages left without all of the entourage that was to be accompanying the president. Governor Campbell of Ohio and his staff had fallen asleep in the carriage directly in front of the president's carriage. When they woke up, they realized that part of the entourage was gone—the most important part. The governor sent one of his aids to obtain the details of the reception and the president's whereabouts. After more than an hour, the committee informed him that the president was at the Monongahela House hotel.

When it was time for the president to leave the Monongahela House and attend the Scotch-Irish Congress at Exposition Hall, things only got worse. As the carriages lined up outside the hotel, the officers of the Eighteenth Regiment were patiently waiting for all of the dignitaries to board their carriages. Waiting was not what Harrison wanted to do. The president called out in a harsh voice to

Captain John Penny from his carriage. He demanded to know why they were not moving, and the captain explained the situation to the president. Harrison did not want to hear about it and told the captain, "Well go ahead; I don't want to stay here." As the president's carriage pulled away, the dignitaries and members of the reception committee scrambled to get into their carriages. For the next ten minutes, carriages were speeding through town trying to catch up to Harrison.

By the time that everyone had reached Exposition Hall, the reception committee was disgusted with the president's imperious behavior. Around one thousand people were in attendance at the Scotch-Irish Congress. Only around half stood when the president entered and even fewer clapped. Applause was so thin that it was described as chilly by the *New York Times*.

About three hundred people were gathered outside to watch the president leave the congress. The crowd allegedly "gazed on the chief official of the nation with pathetic indifference." A handful of old veterans saluted him as he passed, and Harrison tipped his hat in return. When he entered his carriage, Harrison again demanded that they leave without the rest of his escort. The dignitaries raced through the streets again to catch up with the impatient president before he reached the train station. When Harrison finally left, the *Times* stated that he would not soon be asked to visit the city again.

MARRIED OVER PITTSBURGH

Unusual weddings are nothing surprising today. On a semiregular basis the media provides a lighthearted distraction from the traditional "bad" news by showing or describing an unusual wedding ceremony. I remember on one occasion watching a video of a couple who was married and immediately bungee jumped off a bridge. In

the early 1930s, however, unusual weddings were not that common. One Pittsburgh wedding from that time was different enough to make it into the *New York Times*.

On July 6, 1930, J.R. Bazley and Helen McLeod got married three thousand feet above Pittsburgh. The Reverend James S. Jewell performed the ceremony in an eighteen-passenger trimotored plane. Thirteen relatives accompanied the couple in the flight that departed from Bettis Field near McKeesport. Bazley worked with airplanes as an employee of the Curtiss-Wright Airplane Company. Having an aerial wedding seemed like a good idea. More than three thousand spectators watched the plane from the ground.

A HEAD-ON COLLISION

Two electric streetcars had a terrible head-on collision at Bryant Station on March 27, 1909. Both cars were part of the Pittsburg & Butler Street Railway. The accident occurred at a curve in the track. Apparently one of the motormen misunderstood a signal and believed that he was clear to go around the bend. By the time the operators of the cars saw each other, it was too late. Though they slammed on their brakes and slowed a little, the cars still slammed directly into each other at a high rate of speed. The cars were knocked off the tracks but did not tumble off the steep embankment next to the line. Three people

died on the scene, including one of the motormen and a fare collector. Two others, including the other motorman, were critically wounded. Fifteen other passengers suffered a varying degree of minor injuries.

THE NEW YEAR STARTED WITH A BANG!

January 1, 1900, brought a surprise for some residents of Pittsburgh's Knoxville neighborhood. Apparently, dangerously combustible sewer gas had built up under the street. Some unknown source caused it to ignite and

explode. Twelve houses on Rochelle Street were completely obliterated. A stable and five houses were destroyed on Long Alley. A dozen more were damaged on Zara Street and Long Alley. Though there was thousands of dollars worth of damage, no one was hurt.

BOXER ATTACKED IN THE RING—WITH AN AXE!

On June 30, 1890, a prizefight was being held to the west of Pittsburgh in Shousetown (now Glenwillard), Crescent Township. Both of the contestants were known as good fighters. Elmer Grant was from the Beaver Falls area, while his opponent, Fred Wise, was a native of New Brighton. The fight turned out to be a short one. Within forty-five seconds, Grant knocked Wise down seven times. Essentially every punch that Grant threw took Wise off his feet. After the seventh time, he was down for good.

The quick fight then took a turn toward the surreal when Wise's younger brother jumped into the ring with an axe. (Why he brought an axe to a boxing match is anyone's guess.) He swung the blunt end of the axe at Grant's head but missed and struck him in the back instead. Grant was stunned and fell to the ground. Before any of the witnesses could even attempt to apprehend the younger Wise, he jumped back out of the ring, pulled out a revolver and challenged anyone to try to stop him. The bystanders cleared out of his path, and he escaped. The incident was

reported to police, but it is not known whether they ever arrested him.

The fight was declared a draw by the referee. Grant's supporters were very angry with the decision. They began to threaten the referee. For a few moments the crowd seemed like it was about to take hold of him and force him to change his decision, but he managed to get away.

FOUND IN THE MON: GEORGE WASHINGTON'S RING

George Washington's travels and exploits in western Pennsylvania are well known and well documented. A reporter from the *Pittsburgh Dispatch*, however, might have uncovered previously unknown evidence of Washington's time in the region. In July 1891, A.P. Bowser of the Pittsburgh and Lake Erie Railroad introduced the unidentified reporter to a man who claimed to have George Washington's signet ring. Jesse Wickes lived on Fourth Avenue and was in possession of the ring. He told the reporter that his now deceased brother, Harry Wickes, discovered it in 1883 on a sandbar in the Monongahela River between the Smithfield Street Bridge and the Pennsylvania Railroad Bridge. (A sandbar did occasionally exist in that location when water levels were low.) The inside of the ring was lined with gold, and the initials G.W. were etched inside. The actual seal was cast iron and bore a shield and crown. Washington's seal had a similar design, and his shield had stripes or bars. The

article that the reporter wrote does not go into that level of description about the seal on the ring. It did describe the ring as large, and Washington was known to have large hands. Washington also crossed the Monongahela several times. It is theoretically possible that he lost the ring along the way. There is no way to know for sure because the ring's current whereabouts are unknown. The reporter was the first "outsider" to see it since the discovery, and Wickes demonstrated no interest in displaying it to anyone else.

DANGEROUS CITY

The *New York Times* ran an article on January 15, 1906, that illustrated just how dangerous industrial jobs were in the city of Pittsburgh. In the previous year, 17,700 people had been killed or maimed while performing industrial jobs in the city. As one might expect, 9,000 of those casualties occurred in iron and steel mills. Four thousand casualties occurred in other mills, shops and factories. Railroads claimed 4,300 victims. The final 400 were injured or killed in coal mines. The companies blamed the high casualty rates on careless employees, but the workers had a different story. Very little money was spent on safety precautions and training because it was actually cheaper just to get another worker if something happened.

CIRCUS TALES

Circuses are, by nature, places where the unusual occurs. In the late 1800s and early 1900s, at the height of their popularity, there was never a shortage of newspaper coverage of circus happenings, whether they were bizarre, funny or tragic. Some of these odd circus stories happened in Pittsburgh. In the spring of 1905, the Barnum and Bailey Circus came to town, and it was not without controversy. When residents of Pittsburgh's wealthy East End neighborhoods learned that the circus was seeking a permit to set up near their homes, they immediately campaigned against it. Judge James Young ruled in their favor and granted an injunction to prevent the public safety director from granting the circus a permit for a lot on Winebiddle Street. Eventually the circus set up elsewhere in the East End. Another problem occurred at the end of May when the circus's Japanese acrobats learned of Japan's victory over Russia in the Russo-Japanese War. The acrobats decided to take the day off and celebrate, even if they were fired. They wandered away from the circus and did not come back for hours. The police were actually sent to look for them at one point. It was a great disappointment for those who had hoped to see the acrobats at the circus.

The residents of the East End may have had a point in their protests, because two years later, when the circus had returned, a leopard escaped and started to wander the neighborhoods. Several dogs were killed by the leopard in just two days, and

Henry Klopperburg was attacked on the evening of June 30. Klopperburg had managed to strike the leopard several times after it had pounced on him, and it ran away. Citizens of the East End were warned not to walk around without their firearms, and police patrols were stepped up. There was no follow-up information about when the leopard was finally captured. Another circus animal attack occurred in Pittsburgh on July 27, 1942. During the opening act of the Ringling Bros. and Barnum & Bailey Circus, a lion mauled a trainer named Vincent Sunday. He was bitten and slashed on his right knee and thigh.

Several well-known circus performers also died in Pittsburgh, though not under the big top. In August 1888, Virginia Sherwood died of consumption at the home of her sister-in-law, Mrs. John McLaughlin. She was one of the greatest equestrians of her day, known for her daring leaps and skills at handling a horse. One of the country's most famous clowns also died on the South Side in August 1930. Despite his decades of work in a variety of circuses, seventy-five-year-old Dan Ducrow was living in a tiny attic in a boardinghouse on Sarah Street. Born in California in 1855, he had been performing since the age of nine. A month before his death, he attempted to perform at the Shriner's picnic at Kennywood but collapsed in the hot sun. He was taken back to his attic and never fully recovered. The *New York Times* and other papers around the country ran articles about his death. Prince Dennis, known as the world's smallest boxer, died at Allegheny General Hospital on March 6, 1944. His real name was Dennis McCarthy, and he was only thirty-two inches high and weighed fifty-five pounds. Prince Dennis had performed at numerous circuses and carnivals throughout the country, but his home was on Reedsdale Street. He was only forty-four years old when he passed.

In July 1956, the "Greatest Show on Earth," as everyone had known it, came to an end. The management of the Ringling Bros. and Barnum & Bailey Circus announced, while performing in Pittsburgh, that it would be the last stop of their traditional tented show. They would no longer

continue the show under the big top because of a series of financial problems, difficulties with the unions and competition from other entertainment sources, such as television. The final show was held in the city on July 16. After the circus returned to its winter home in Florida, it was reorganized to perform indoors and in arenas, and the large tents and other trappings of the show were retired.

A PHANTOM HEARTBEAT

In Canton Township, Washington County, an urban legend has been passed down about a ghostly heartbeat that can be heard near the site of an old oil derrick. According to the story, in the late 1800s or early 1900s, a man was working at the top of the derrick when he somehow lost his balance and hold on the structure. He plunged to his death on the ground below. The derrick, which was located on Pump Station Road, was said to be haunted after the worker's death. Other men reportedly heard the worker's faint heartbeat with regularity. Numerous other curious visitors came to hear the ghostly heartbeat for years after the incident.

THE SCHOOL BURNED DOWN

Early on the morning of February 8, 1933, fire destroyed the five-room Mollenauer Public School in what was then

Bethel Township. The school was located along Library Road. Firemen believed that an overheated furnace had sparked the blaze, and by the time the fire department was summoned, the entire building was engulfed. The situation was made worse because the school failed to have the suggested fire hydrants installed nearby. Chief Lepkowski made a point to mention the ignored suggestion to the *Pittsburgh Press*.

Strong winds blew burning embers hundreds of feet, and the firemen feared that surrounding buildings could catch fire. Fire companies from Castle Shannon and Broughton were called in to assist. Ultimately the entire structure was destroyed. Even though it was early, dozens of children gathered to watch the school burn. They seemed to have mixed emotions about the event. One girl told the reporter from the *Pittsburgh Press*, "I'm sorry to see our school burn." When the reporter asked a rather excited little boy what he thought, the young man sarcastically said, "Boy, ain't that hot?"

The Tale of the "H"

Pittsburgh, Pennsylvania, is the only city in America that ends in "burgh." All of the other "burgs" are spelled without an *h*. Even nearby towns such as Canonsburg and Greensburg end without an *h*. There was a brief period of time, however, when even Pittsburgh lost its distinctive

final letter. If you have ever seen old newspapers, books or documents from the years 1890 to 1911 you will notice that there is no *h* on Pittsburg. We can blame the confusion on President Benjamin Harrison. In 1890, he established the U.S. Board of Geographic Names to standardize spelling and naming procedures for cities, towns and geographic features. One of those standardizations was to remove the *h* from the end of any town that ended in "burgh." Almost immediately a campaign began to restore the historical spelling with the *h*. Many residents continued to spell it with the *h* on unofficial documents and in personal writings. After more than twenty years, the board finally relented and restored the original spelling of Pittsburgh. It was the only exception to the rule.

SELECTED BIBLIOGRAPHY

ARCHIVAL MATERIALS

Charles M. Stotz Papers, MSS 21. Library and
 Archives Division, Senator John Heinz Pittsburgh
 Regional History Center.
George Swetnam Papers, 1999.0039. Library and
 Archives Division, Senator John Heinz Pittsburgh
 Regional History Center.
Magoc, Chris J. *Steel Industry Heritage Association Ethnographic
 Survey of the Following Communities in the Allegheny-
 Kiskiminetas River Valley: New Kensington, Arnold, Braeburn,
 Tarentum, Brackenridge, Natrona, West Natrona ("Ducktown"),
 Natrona Heights, With Brief Forays Into: Vandergrift, Buffalo
 Township.* N.p.,1993.
Michael A. Musmanno Papers. University Archives and
 Special Collections, Gumberg Library, Duquesne
 University.

ARTICLES

"All Had Lost an Eye." *Pittsburg Dispatch*, August 3, 1891.

"Another Confession by the Murderer Ortwein." *New York Times*, August 5, 1874.

"Attacked in the Ring." *New York Times*, July 1, 1890.

"At Work in Earnest." *Pittsburg Dispatch*, May 21, 1890.

"Bandits Bomb Pay Car, Obtaining $102,000 in Cash." *Los Angeles Times*, March 12, 1927.

Barcousky, Len. "Eyewitness 1818: No Jail Could Hold This Pittsburgh Thief." *Pittsburgh Post-Gazette*, March 22, 2009.

"Beaver Man Shot Stealing Chickens." *Pittsburgh Press*, November 21, 1935.

"Bedeviled: Proctor & Gamble Renews Efforts to Halt Satan Rumor." *Pittsburgh Post-Gazette*, November 7, 1984.

Bennett, Joe. "Pittsburgh's Hard-Luck Bridge." *Pittsburgh Press Roto*, June 5, 1977.

"Blow Up Trolley Car." *New York Times*, August 11, 1911.

"Bomb Armored Pay Cars, Flee with $102,000; Bandit's Blast Tears Up Road; 5 Guards Hurt." *Chicago Daily Tribune*, March 12, 1927.

"The Boyd's Hill Murder." *New York Times*, September 25, 1865.

"Burned the Balloon." *Pittsburg Dispatch*, July 26, 1891.

"Chinese Tong Conference to Renew Ancient Rituals." *Pittsburgh Press*, April 21, 1935.

"Church Leaders Call Weeping Icon a Sign." *Valley Independent*, August 1, 1988.

"Counterfeiting in Prison." *New York Times*, October 19, 1897.

"Dan Ducrow, 75, Dies; Famous Circus Clown." *New York Times*, August 13, 1930.

Davis, Mrs. Elvert M. "Fort Fayette." *Western Pennsylvania Historical Magazine* 10, no. 2 (1927): 65–84.

"The Dead at Pittsburg." *Atlanta Constitution*, January 11, 1889.

"Decapitation." *Pittsburgh Daily Gazette and Advertiser*, November 21, 1866.

"Diamond Thief Escaped from Jail." *New York Times*, March 24, 1894.

"Dragged by a Street Car." *Pittsburgh Dispatch*, October 31, 1889.

"Earthquake Felt Here; Eastern Part of U.S. Hit." *Pittsburgh Post-Gazette*, November 1, 1935.

"Electrical Freaks." *New York Times*, January 24, 1890.

"Execution in Pennsylvania." *New York Times*, February 24, 1875.

"Father John Kluchko Tells of Weeping Icon." *Valley Independent*, January 4, 1989.

"Final 'H' for Pittsburgh." *New York Times*, August 9, 1911.

Fitzpatrick, Dan. "Shielding Pittsburgh Business: Half a Century Ago, Pittsburgh Was Considered to Be a Likely Military Target." *Pittsburgh Post-Gazette*, September 23, 2001.

"Five Men Killed by Boiler Explosion in Pittsburg."
Cranberry Press-New Jersey, March 22, 1899.

"Fortune Tellers in Trouble at Pittsburgh." *New York Times*,
June 21, 1859.

"Fortune Telling." *Beaver Weekly Argus*, May 30, 1860.

Gardner, Bob. "Anniversary of 'Weeping' Marked." *Valley
Independent*, August 15, 1991.

———. "Weeping Icon Draws Many to Church in Belle
Vernon." *Valley Independent*, August 20, 1988.

Gruszczynski, Joseph. "The Phantom Encampment."
Keystone Folklore Quarterly 6, no. 4 (1961): 2.

Halaas, David, and Andrew Masich. "Rediscovering Lewis
& Clark." *Western Pennsylvania History* (Winter 2003–04).

"The Hamnett Tragedy." *New York Times*, May 5, 1874.

"Harrison Chills Pittsburgh." *New York Times*, June 1, 1890.

"Held Up, Swallows Gems." *New York Times*, May 20,
1925.

"The Hero of Allegheny City." *New York Times*, May 13,
1890.

"The Homestead Tragedy: Alleged Confession by the
Murderer Ortwein." *New York Times*, August 7, 1874.

Jenkins, Philip. "The Ku Klux Klan in Pennsylvania,
1920–1940." *Western Pennsylvania Historical Magazine* 69,
no. 2 (1986), 120–37.

"Killed or Maimed, 17,700." *New York Times*, January
15, 1906.

"Laboratory Sheep Diseased, Stolen." *Pittsburgh Press*,
February 29, 1932.

"Left Them Half Married." *Pittsburg Dispatch*, August 7, 1891.

Lelik, Emma Jene. " Phenomena of the Weeping Icons."
Valley Independent, August 4, 1988.

"Leopard Loose in a City." *New York Times*, July 2, 1907.

"Lightning Kills Two Balloonists, Several Injured and
Crafts Fired as Elements Play Havoc in National
Elimination Race." *Wisconsin Rapids Daily Tribune*, May
31, 1928.

Lowry, Patricia. "Who Built the Big Boat?" *Pittsburgh Post-
Gazette*, August 3, 2003.

"Mangled by Enraged Lion; People Look on While the
Maddened Beast Rends Its Prey." *Ogden Standard*, August
28, 1907.

"Many Houses Wrecked; Much Damage Caused by
Explosion of Sewer Gas Near Pittsburg." *New York Times*,
January 2, 1900.

"Married in Airplane." *New York Times*, July 7, 1930.

McCarthy, Bill. "One Month in the Summer of '63:
Pittsburgh Prepares for the Civil War, Part II." *Pittsburgh
History* (Winter 1998–99), 156–69.

"Melancholy Event." *Daily Morning Post*, October 20,
1854.

"Men, Women, and Children Perish in Runaway Car."
Bismark Tribune, December 25, 1917.

Merriman, Woodene. "Inn to the Past: Downtown
Cantonese Restaurant Points Back to City's Vanished
Chinatown." *Pittsburgh Post-Gazette*, December 9, 2003.

"Midget Boxer Dies." *New York Times*, March 6, 1934.

"Mollenauer School Left in Ruins as Flames Sweep Structure." *Pittsburgh Press*, February 8, 1933.

"The Murder of David Fleming Not True." *Daily Morning Post*, October 23, 1854.

"Murderers Saw a Ghost." *New York Times*, September 16, 1907.

"A Mysterious Murder." *New York Times*, August 27, 1865.

"Nab 2 Suspects, Set Trap for 4 in Pay Car Blasting." *Chicago Daily Tribune*, March 13, 1927.

"New Tong Murders; 500 Chinese Seized." *New York Times*, September 19, 1925.

O'Neill, Brian. "Ghosts of Old Allegheny Still Walk the North Side." *Pittsburgh Press*, October 31, 1991.

Ove, Torsten. "Mafia Has a Long History Here; Organized Crime Grew from the Bootlegging Days of the 1920s Despite Internal Struggles." *Pittsburgh Post Gazette*, November 6, 2000.

"Pastors Preach in Dark." *New York Times*, January 21, 1921.

"Pittsburgh Area Shaken." *New York Times*, November 1, 1935.

"Pittsburghers Flee From Falling Plane." *New York Times*, January 6, 1934.

"Plumber Completes 10-Inch Telescope." *New York Times*, November 24, 1930.

Potter, Chris. "You Had to Ask." *Western Pennsylvania History* (Fall 2003).

"Quit Circus to Celebrate." *New York Times*, May 30, 1905.

"Raided 13 Barber Shops." *New York Times*, May 14, 1906.

"Raids in Chinatown Follow Tong Clash." *New York Times*, October 10, 1924.

Raskin, R.A. "The Big Top Folds Its Tents for Last Time." *New York Times*, July 17, 1956.

"Rebel Against a Circus." *New York Times*, May 14, 1905.

"A Remarkable Story." *New York Times*, December 4, 1876.

Rodgers-Melnick, Anne. "Religion of Materialism: Fear of Satanism Is Fueled More by Rumor than by Fact." *Pittsburgh Press*, September 3, 1989.

———. "Satanism: 'More Secret Than the Underworld.'" *Pittsburgh Press*, September 5, 1989.

"Runaway Trolley Kills 16." *New York Times*, December 25, 1917.

"Saving Child's Life, Autoist Breaks Law." *New York Times*, June 8, 1925.

Sebak, Rick. "Gangster History in Bethel Park!" *Pittsburgh Magazine*, July 23, 2009.

"17 Die in Street Car Accident." *Oakland Tribune*, December 24, 1917.

"Shaken by an Earthquake." *New York Times*, June 1, 1897.

"Sketch of the Life of Mrs. Grinder—Is She a Professional Poisoner?" *New York Times*, September 3, 1865.

Smith, Martin. "Costumed Child Molester? City Police Doubt It." *Pittsburgh Press*, June 4, 1981.

———. "Rash of 'Molester Sightings' Hits Other Cities." *Pittsburgh Press*, June 5, 1981.

"Special Pilgrimage to See Weeping Icon." *Valley Independent*, July 28, 1961.

"Steal Infected Rabbits." *New York Times*, December 21, 1930.

"A Strange Accident: Plugs Give Way in Oil Well and One Man Killed." *New York Times*, January 18, 1890.

"Street Cars in a Wreck." *Nebraska State Journal*, July 7, 1897.

"The Stricken Picnickers." *Pittsburgh Telegraph*, July 5, 1878.

"A Terrible Disaster." *Aspen Weekly Times*, January 12, 1889.

"Terrific Summer Storm." *New York Times*, July 5, 1878.

"Three Alleged Tong Gunman Held, Three Sought in Shooting." *Pittsburgh Press*, January 20, 1925.

"Three Girls Killed, Many Badly Hurt." *Spartanburg Herald-Journal*, August 8, 1912.

"Three Killed as Electric Cars Crash." *New York Times*, March 28, 1909.

Thomas, Mary Ann. "Springdale Looking to Immortalize Local Legends." *Aspinwall Herald*, March 22, 2010.

"Tongmen Kill Nine as War Flares Anew." *New York Times*, March 25, 1927.

"Tong War Spreads into Five States." *New York Times*, August 26, 1925.

"Tornado at Pittsburgh." *Indiana Weekly Messenger*, January 16, 1889.

"Umpire Attacked by Mob." *New York Times*, May 27, 1897.

"Unique Accident in Pittsburgh." *New York Times*, September 29, 1897.

"Valley View Observatory Historical Marker" *Guide Star*, August 1998.

"Virginia Sherwood Dead." *New York Times*, August 27, 1888.

"Washington's Signet Ring." *Pittsburgh Dispatch*, July 21, 1891.

"Wreck and Ruin in Pittsburgh; Scores of Persons Killed and a Large Number Injured by Falling Buildings." *Rolla New Era,* January 12, 1889.

BOOKS

Begg, Paul. *Jack the Ripper: The Definitive History*. New York: Longman, 2003.

Coleman, Loren. *Mysterious America, Revised Edition*. New York: Paraview Press, 2001.

Davison, Elizabeth M., and Ellen B. Mckee. *Annals of Old Wilkinsburg and Vicinity: The Village, 1788–1888*. Wilkinsburg, PA: Group for Historical Research, 1940.

Ellis, Bill. *Aliens, Ghosts and Cults: Legends We Live*. Jackson: University Press of Mississippi, 2001.

———. *Lucifer Ascending: The Occult in Folklore and Popular Culture*. Lexington: University Press of Kentucky, 2004.

———. *Raising the Devil: Satanism, New Religions, and the Media*. Lexington: University Press of Kentucky, 2000.

Evans, Stewart, and Paul Gainey. *Jack the Ripper: First American Serial Killer*. New York: Kodansha International, 1998.

Fort, Charles. *The Book of the Damned: The Collected Works of Charles Fort*. New York: Penguin Group, 2008.

Glasco, Laurence A., ed. *The WPA History of the Negro in Pittsburgh*. Pittsburgh: University of Pittsburgh Press, 2004.

Hadley, S. Trevor. *Only in Pittsburgh*. Cincinnati: Educational Publishing Resources, 1994.

Hogeland, William. *The Whiskey Rebellion: George Washington, Alexander Hamilton, and the Frontier Rebels Who Challenged America's Newfound Sovereignty*. New York: Simon & Schuster Paperbacks, 2006.

The Iron City: A Compendium of Facts Concerning Pittsburgh and Vicinity, for Strangers and the Public Generally. April, 1867. Pittsburgh: G.W. Pittock and K. McFall, 1867.

Jenkins, Philip. *Decade of Nightmares: The End of the Sixties and the Making of Eighties America*. Oxford: Oxford University Press, 2006.

————. *Hoods and Shirts: The Extreme Right in Western Pennsylvania 1925 to 1950*. Chapel Hill: University of North Carolina Press, 1997.

Keith, Jim. *Black Helicopters Over America: Strikeforce for the New World Order*. Lilburn, GA: IllumiNet Press, 1994.

————. *Black Helicopters II: The Endgame Strategy*. Lilburn, GA: IllumiNet Press, 1997.

Long, David N. *The Rise and Fall of the Ku Klux Klan in Western Pennsylvania in the 1920s*. Master's thesis, Duquesne University, 2009.

Loucks, Emerson Hunsberger. *The Ku Klux Klan in Pennsylvania: A Study in Nativism*. Harrisburg, PA: Telegraph Press, 1936.

Mann, Henry. *Our Police: A History of the Pittsburgh Police Force Under the Town and City*. Pittsburgh: Henry Fenno, 1889.

Nesbitt, Mark, and Patty A. Wilson. *Haunted Pennsylvania: Ghosts and Strange Phenomena of the Keystone State*. Mechanicsburg, PA: Stackpole Books, 2006.

Odell, Robin. *Ripperology: A Study of the World's First Serial Killer and a Literary Phenomenon.* Kent, OH: Kent State University Press, 2006.

Riordan, Timothy B. *Prince of Quacks: The Notorious Life of Francis Tumblety, Charlatan and Jack the Ripper Suspect.* Jefferson, NC: McFarland, 2009.

Swetnam, George. *Devils, Ghosts, and Witches: Occult Folklore of the Upper Ohio Valley.* Greensburg, PA: McDonald/Sward Publishing, 1988.

———. *Pittsylvania Country.* New York: Duell, Sloan & Pearce, 1951.

Trapani, Beth E. *Ghost Stories of Pittsburgh and Allegheny County.* Reading, PA: Exeter House Books, 1994.

Trinklein, Michael J. *Lost States: True Stories of Texlahoma, Transylvania, and Other States That Never Made It.* Philadelphia: Quirk Books, 2010.

WEBSITES

Bovsun, Mara. "The Turnpike Phantom." NYDailyNews.com. http://www.nydailynews.com/news/ny_crime/2007/09/23/2007-09-23_the_turnpike_phantom-2.html (accessed June 1, 2010).

Casebook: Jack the Ripper. http://www.casebook.org/index.html (accessed August 2, 2010).

"Tesla's Death Ray." *Letters of Note.* http://www.lettersofnote.com/2010/07/teslas-death-ray.html (accessed July 19, 2010).

About the Author

Thomas White is the university archivist and curator of special collections in the Gumberg Library at Duquesne University. He is also an adjunct lecturer in Duquesne's History Department and an adjunct professor of history at La Roche College. White received a master's degree in public history from Duquesne University. Besides the folklore and history of western Pennsylvania, his areas of interest include public history and American cultural history. He is the author of *Legends and Lore of Western Pennsylvania*, *Forgotten Tales of Pennsylvania* and *Ghosts of Southwestern Pennsylvania*, all published by The History Press.